The Toaster Project

MAKE ME SOME TOASTERS !!

OR OTHER SIMILAR
Things.

Enjoy —

Dazlin

The Toaster Project

OR A HEROIC ATTEMPT TO BUILD A SIMPLE ELECTRIC APPLIANCE FROM SCRATCH

Thomas Thwaites

PRINCETON ARCHITECTURAL PRESS · NEW YORK

Left to his own devices
he couldn't build a
toaster. He could just
about make a sandwich
and that was it.

—Douglas Adams, *Mostly Harmless* (1992)

For Merle, Bette, Vito & Felix

Published by
Princeton Architectural Press
37 East 7th Street, New York, NY 10003

For a free catalog of books call 1-800-722-6657
Visit our website at www.papress.com

Editor: Sara Bader
Designer: Paul Wagner

Special thanks to: Bree Anne Apperley, Nicola Bednarek Brower,
Janet Behning, Fannie Bushin, Megan Carey, Becca Casbon,
Carina Cha, Tom Cho, Penny (Yuen Pik) Chu, Russell Fernandez,
Jan Haux, Linda Lee, John Myers, Katharine Myers, Margaret Rogalski,
Dan Simon, Andrew Stepanian, Jennifer Thompson, Joseph Weston,
and Deb Wood of Princeton Architectural Press
—Kevin C. Lippert, publisher

Library of Congress Cataloging-in-Publication Data
Thwaites, Thomas, 1980–
The toaster project, or A heroic attempt to build a simple electric
appliance from scratch / Thomas Thwaites. — 1st ed.
 p. cm.
Includes bibliographical references.
ISBN 978-1-56898-997-6 (alk. paper)
1. Thwaites, Thomas, 1980—Themes, motives. 2. Manufactures—
Miscellanea. I. Title. II. Title: Heroic attempt to build a simple electric
appliance from scratch.
NK1447.6.T49A35 2011
683'.83—dc22

 2011006094

Foreword
by David Crowley

Where do the products that fill our lives come from?
"China" is, of course, the standard answer to this
question. The "dragon economy's" mammoth factories
are high in our consciousness, drawing the attention
of environmentalists worried about the effects of
breakneck industrialisation and Western politicians
troubled about competition.

But "China" is an inadequate answer. Where
do our things really come from? What lies behind
the smooth buttons on your mobile phone or the
elegant running shoes on your feet? What is involved
in extracting and processing the materials that give
themselves up from the earth so reluctantly? Where
does the copper in your "Made in China" kettle come
from? Were the electronic components and integrated
circuits in your TV remote control assembled by
machine or by hand? And what exactly has been
integrated in that circuit anyway?

We rarely ask these kinds of questions. Perhaps the nature of our consumer culture makes us averse to them. Consumer goods play a clever game of "hide and show" with us: they call our attention, promising to satisfy our wants. Yet, at the same time, they veil their origins. Appearing to have no history or past, they materialise on the shelves of our shops as if by magic. This is what Walter Benjamin described as the "phantasmagoria" of commodity culture. Modern societies, it seems, not only forget the material and practical origins of the commodities they consume, they seem to have elevated them to minor deities.

In *The Toaster Project* Thomas Thwaites set himself the task of making one of the most commonplace consumer goods from scratch. This meant not assembling this modest appliance from other existing components but extracting and processing the materials from which the parts of a toaster are made. This book records his major failures and minor triumphs.

Thwaites begins his mission by dismantling the cheapest toaster on sale in the shops. This is an exercise in reverse engineering, the dark art practiced by military engineers trying to learn enemy secrets and copyright lawyers attempting to track down patent infringements. Thwaites's project rapidly becomes another kind of reverse engineering. Acting alone and eschewing the armoury of techniques available to modern industry, he finds himself in the position of late-medieval man with a limited repertoire of skills and expertise. His most effective guide to the task of smelting iron from ore is, for instance, not the latest issue of *International Journal of Material Sciences* but *De re metallica*, a sixteenth-century treatise.

Modern myths of omnipotence come to seem like hubris when Thwaites is defeated by the task of smelting metals, something first practiced eight thousand years ago. We know more now, don't we? We are more expert than our ancestors, aren't we? Yet, at the same time, we are also reliant on the knowledge they produced. This is pointed out by the philosopher Michel Serres, in *Conversations on Science, Culture, and Time* (1995), when he asks us to consider a new car:

> It is a disparate aggregate of scientific and technical solutions dating from different periods. One can date it component by component: this part was invented at the turn of the century, another, ten years ago, and Carnot's cycle is almost two hundred years old. Not to mention that the wheel dates back to neolithic times. The ensemble is only contemporary by assemblage, by its design, its finish, sometimes only by the slickness of the advertising surrounding it.

Submerged in our toasters are layers of hard-won and deeply practical knowledge—if only we could tap it.

In the spirit of many recent endeavours to limit the techno euphoria of twenty-first-century modernity, Thwaites set some sharp restrictions on his project. Famously, Lars von Trier and Thomas Vinterberg called for filmmakers to return to first principles in their "Vow of Chastity." The obligation to shoot on-site with actors, using natural sound and handheld cameras, would, they argued, ensure a cinematic purity that has been lost in the age of CGI (computer-generated imagery) and lowbrow cinema. Thwaites's particular holy "vows" seem simple—"I must make all the parts of my toaster from

scratch" and "I must make my toaster myself"—but like most rules, they require interpretation. Making a toaster "on his own" means not employing other people, but in the world today, can anyone ever really be entirely independent, forgoing the expertise and services of others? Surely that's the lonely territory of antimodern hermits like Theodore Kaczynski, author of another vow of chastity, "The Unabomber Manifesto." *The Toaster Project*—over time—becomes a social one: in the course of his quest, Thwaites makes willing conscripts of professors, press officers, and even amiable drunks.

In one regard, Thwaites's *Toaster Project* seems closer in spirit to von Trier's *Five Obstructions* (2003) than the "Vow of Chastity." In this documentary the Danish filmmaker set his friend and mentor, Jørgen Leth, the task of filmmaking under five impossible conditions. Failure was guaranteed, but what made the project worthwhile was Leth's resourcefulness and imagination (as well as his attempts to stretch the rules). Making a toaster from scratch is surely an impossible task, but not a pointless one. Thwaites's project reveals much about the organisation of the modern world, not least the extent to which Britain's industrial capacity has been dismantled. The country's mines, foundries, and factories have become, it seems, another form of phantasmagoria.

Preface

Hello, my name is Thomas Thwaites, and I have made a toaster.

It took nine months, involved travelling nineteen hundred miles to some of the most remote places in the United Kingdom, and cost me £1187.54 ($1837.36). This is clearly rather a lot of time, effort, and money expended for just an electric toaster, but when I say, "I have made a toaster," I mean really *made* it, literally from the ground up; starting by digging up the raw materials and ending with an object that Argos sells for only £3.94 ($6.10).

Actually, this is just a version of the truth. An alternative version would be that I tried and failed to make a toaster. That's not to say I haven't got a rather odd-looking appliance that kind of toasts bread sitting on my kitchen worktop, which cost £1187.54 and caused me to travel around the United Kingdom for nine months. No, what I mean is that although I set

Argos Spring/Summer 2009 catalog

out to make my toaster completely from scratch, I realised along the way that there can be no such thing as "from scratch."

As I sit writing this in a café in London, everything I can see, except maybe some woolen clothes and some wooden furniture, began life as a collection of rocks and sludge, buried in different parts of the world. It's not that this café has a geological theme or something, it's that the rocks and sludge have been transformed in some extremely clever ways, becoming this laptop, or the tasteful wood-effect plastic flooring, or that electric toaster.

How the hell do some rocks become a toaster?

This fundamental question motivated my, let's face it, faintly ridiculous quest to make one from scratch. But I also wanted to explore the grand-scale processes hidden behind the smooth plastic casings of mundane everyday objects, and to connect these things with the ground they're made from. I'm interested in the economies of scale in modern industry, the incremental progression of science and technology, and exploring the ever-widening gulf between general knowledge and the specialisms that make the modern world possible. The point at which it stopped being possible for us to make the things that surround us is long past. Well, that's what it feels like, but is it?

My toaster took me on a journey not only around the United Kingdom, but on a trip through civilisation's history as well, from the Bronze Age to today.

The following pages are the story of that journey, and that toaster.

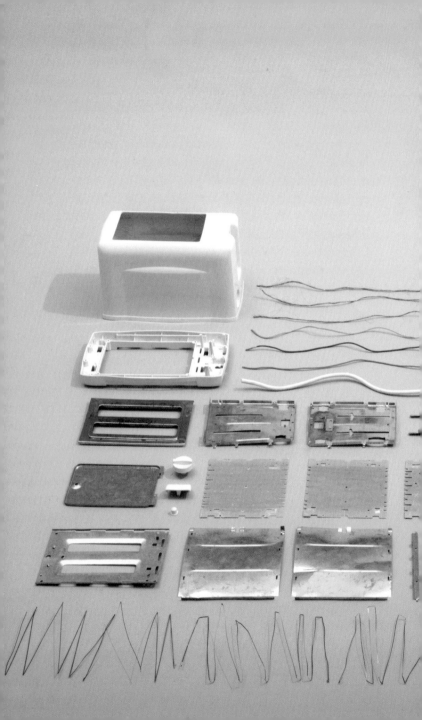

Deconstruction

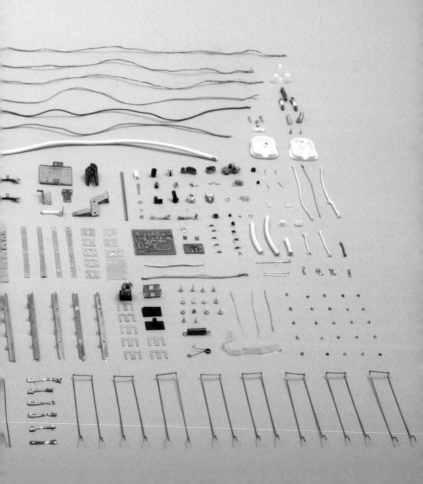

Deconstruction

Reverse engineering is the process of deducing how
something works by taking it apart. Using the potentially
misguided rationale that the cheaper the toaster the
fewer parts it will contain, and thus the simpler it will be
to reproduce, I dismantle the cheapest toaster I can find:
the Argos Value Range 2-Slice White Toaster.

So, let's see what you get for your £3.94[†]…

I dissect my patient into 157 separate parts, but
these parts are made up of sub-parts, which are them-
selves made up of sub-sub-parts. Does the variable
resistor that controls the toasting time count as a single
part? But it's made of eight sub-parts, so perhaps it
should count as eight? Does a capacitor count as one
part or eight? I peel open its thin outer plastic covering,
open the inner metal casing, and rolled up inside are

[†] Price correct at time of writing. There must've been some kind of major
upheaval in the value toaster manufacturing business, because since then the
price has rocketed to £4.47 ($6.95).

What's inside ... a capacitor?

two very thin strips of metal with a metal pin clamped to each, with a strip of weirdly damp paper (soaked in some chemical perhaps?), and a rubbery bung through which the pins poke to be soldered onto the circuit board. And what about the live, neutral, and ground wires of the power cord, coated with colourful plastic and all contained within a white plastic outer sheath? What about the forty-two individual strands of copper, woven together to make up each of the live, neutral, and ground wires in the power cord? If I were to dissect all the components all the way down to their discrete "bits," then I've calculated my toaster-part count would be 404 individual bits.

Things get even more difficult when you start trying to divide the bits according to their material. First, without some serious chemical analysis, it can be impossible to tell if two plastic parts are the same plastic, or in fact different plastics that just look the same. Ditto for the metals.

On top of that practical constraint is the more metaphysical question of what is "the same"? Presumably the brown, blue, and green and yellow striped insulating sheaths of the wires are the same plastic, but they must have different pigments added to colour them. Does this then make them strictly different materials?

The metals, which I thought would be fairly easy to identify, also pose problems. I can pick out the copper OK (though even then some bits of copper appear more "copper" coloured than others), and the bits that are brass coloured are presumably made of brass.

Except that the brass-coloured screws are magnetic, whereas the brass-coloured pins of the plug are not. Steel I know is definitely magnetic. But while some of the silvery metal parts are magnetic and so could be steel, many are not. Depending on where in the toaster they're found, two very similar-looking metals can have different properties, or parts that you'd expect to be made from the same material (like the two springs) are clearly not (they're different colours, for a start).

The materials used in the electronic components are a whole other story. What's the metal inside a transistor? What's that white stuff inside the resistor? The six-coloured bands meticulously painted on every single resistor to show how much they resist the flow of electrons: what are the paints made of? Where do the pigments come from?

If I lump stuff together that roughly looks like steel, that looks like brass, that looks like copper, and so forth, without worrying too much about "slight" differences in colour or consistency, and put plastics together that feel the same, and don't get too lost in all the different exotic materials in the electronics, then I estimate that my toaster is made of at least thirty-eight different materials. Seventeen of these are metal, eighteen are plastic, two are minerals (the mica sheet and talcum powder stuff inside the power cord), and one is just weird (strange wet papery rubber inside the capacitor).

If I got some kind of chemical analyst involved, then the materials count could easily rise to over a hundred.

Bugger.

I'd expected a toaster to be perhaps a little complex, but really, four-hundred-plus parts? One-hundred-plus different materials from God knows where? How could something with this much in it cost £3.94, the price of a hunk of cheese, and not fancy cheese either.

My life's work stretches out in front of me… It wouldn't be so bad, travelling the earth on a quest to extract the hundred materials I need to create my vision, searching for semiconductors amongst icy glaciers, exotic forests, and forgotten lakes. I could grow a beard. After a few years I might tell my story to a fellow traveller and become something of a legend. Eventually someone might start a Facebook group about me, "Fans of the mad bearded Englishman wandering around India trying to make a toaster."

Hmm.

Alternatively, I could make a few minor material substitutions.

To start with, the element: the hot passion within every toaster. No element = no heat = no toast. After some research I discover that for most toasters, the element is made of nickel-chromium resistance wire, sold under the brand name Nichrome. Nichrome is used because it has a high electrical resistance, so it gets hot when an electric current is passed through it, but it's also got a high melting point, so it doesn't melt when it gets hot.

Unfortunately, after a little more research I find that to extract chromium from its ore, one produces a by-product called hexavalent chromium. If you've not

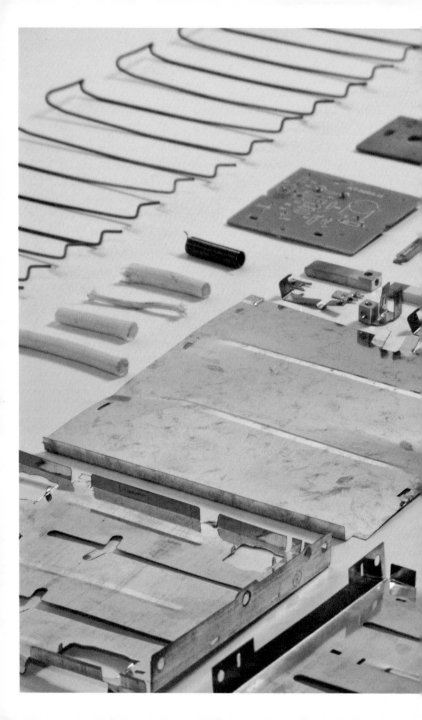

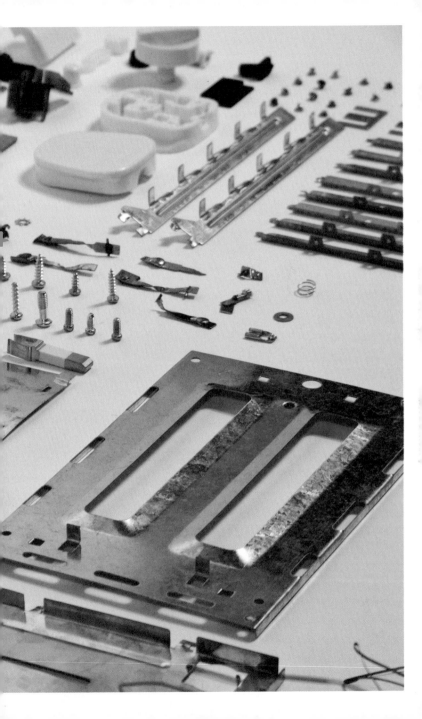

Steel

Mica

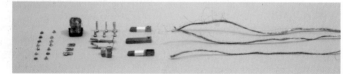

Plastic

Copper

Nickel

seen the film *Erin Brockovich*, next time it happens
to be on TV, have a look. It's based on a true story, and
it's got Julia Roberts in it. She plays the peppy legal
clerk who takes on the giant Pacific Gas and Electric
Company, acting on behalf of some people suffering
from a debilitating sickness caused by the hexavalent
chromium used in the PG&E plant. If Julia Roberts says
the stuff is bad, I think I should avoid it if I can.

Fortunately for my health, heating elements can
also be made from Constantan, an alloy of copper and
nickel consisting of about 55 percent copper and 45
percent nickel. I can replace the dangerous chromium
with copper, which I need for the wires anyway, and
kill two birds with one stone.

Brass, which I'd need for the plug pins, is just
copper with a touch of zinc. Zinc sounds rather exotic.
I don't see much advantage to it, to be honest. I'll lose
the zinc and just use plain old copper. And so on…
I pare down my materials to the bare minimum from
which I think I can make a toaster that retains the
essence of "toasterness." These are: steel, mica, plastic,
copper, and nickel.

I'll travel to a mine where iron ore is found, collect
some ore, somehow extract the iron myself, and then
somehow change it into steel. The same for the mica,
copper, and nickel. I'll need to get hold of some crude oil
from which to refine the molecules for the plastic case.

I'm going to need some advice…

* * *

From: Thomas Thwaites <thomas@thomasthwaites.com>
To: j.j.cilliers@imperial.ac.uk
Date: 7 November 2008 02:08
Subject: **The Toaster Project?**

Dear Professor Cilliers,

I'm a 2nd year postgraduate design student at the Royal College of Art (just across the Royal Albert Hall from your office at Imperial College). Sorry for contacting you just "out of the blue," but I'm trying to build an electric toaster from raw materials and I'm in need of some advice.

As a first step I think I need to get an idea of whether the project is hopelessly ambitious, or just ambitious. I was wondering if I could perhaps come to the Royal School of Mines and briefly discuss the shape of the project?

Yours Sincerely,
Thomas

From: Cilliers, Jan J I R <j.j.cilliers@imperial.ac.uk>
To: thomas@thomasthwaites.com
Date: 7 November 2008 07:16
Subject: **Re: The Toaster Project?**

Thomas,

This is utterly fabulous! Come see me whenever you can, I would be happy to help in whatever way I can.
Call me on 07 ——————— first, or email.

Jan

The Royal School of Mines, Imperial College of Science
and Technology, London

Professor Jan Cilliers, Chair in Mineral Processing and director of the
Rio Tinto Centre for Advanced Mineral Recovery

The Royal School of Mines, Imperial College, London
Senior Common Room
Friday, 7 November 2008 (Lunchtime)

Professor Jan Cilliers holds the Chair in Mineral Processing at the Royal School of Mines at Imperial College and is the director of the Rio Tinto Centre for Advanced Mineral Recovery. He's also a jolly nice chap; he bought me fish and chips at the Imperial College Senior Common Room. The following is a transcript of our conversation. For succinctness I've removed about a half hours' worth of me saying "err," "um," "well," and "you see."

PROFESSOR CILLIERS: So, this toaster thing. In toaster terms I have lived through several generations of toasters. The first toaster we had in my house had little doors that opened up — and when you opened the door the bread turned itself. Do you remember those?

ME: Um, not really, no.

The reason I ask is that one of these toasters would be much simpler to do than a modern toaster. I assume it's not going to pop up, right?

I would quite like to try and make it pop up. Bloody hell.

I was even thinking, well at some point somebody made the first transistor or resistor or capacitor or something, so it must be possible to make these things yourself.

You're going to plug it in and you want it to work? So are you going to make the cable or...?

[I nod my head.]

Really. Right, well. How much time have you got?
Until the degree show next summer.
I see. So, why a toaster?
Well, I guess because they break all the time.
[This was not a brilliant answer. I knew it,
and Professor Cilliers clearly expected more
of an answer to a question quite fundamental
to the project. At a loss, I played the artist
card...] And well, you know, a toaster just
feels right.
[Oh dear. A toaster "feels" right.]

* * *

SO, WHY A TOASTER?

What I didn't say to Professor Cilliers at the time but have since discovered is something along the lines of the following. The reason that I want to create a toaster, specifically an electric toaster, is because the electric toaster, like no other object, seems to me to encapsulate something of the essence of the modern age. To understand how they achieved this status, we'll have to look back at how they came to be such a mainstay of kitchen life for the peoples of the world who toast.

Toast: A Brief History

The first toaster, of course, is a bit of a grey area—probably being nothing more than a stick with a piece of bread on the end of it held over a fire. In ancient Rome toasting was a popular way of preserving bread; *tostum* is Latin for burning. Fact.

Toasting really took off, however, with the invention of the electric toaster at the beginning of the 1900s. The years before had seen electricity begin to change people's way of life. The Edison General Electric Company established the first central power station in New York in 1882 to power the eight hundred electric bulbs of its subscribers. The same year the first power station in London (near Holborn viaduct) was switched on, providing electricity for some electric streetlights and a few nearby private houses. Twenty years later, and electricity suppliers faced a problem: there were pronounced peaks and valleys in the demand for their electricity. Electrical consumption rose slightly in the early morning, fell to almost nothing during the day, and then peaked again as it got dark in the evening.

However, to meet morning and evening demand, suppliers had to continue generating at peak level output throughout the day. Big power stations can't be adjusted up or down from hour to hour, and storing the quantities of energy they generate wasn't (and generally still isn't) practical or economical. Thus, a way to increase demand outside of peak hours was needed, and electrical appliances proved successful at doing just that. If you can't, or don't wish to, cut back production, then try to manufacture demand—the story of the twentieth century?

In the early 1900s, AEG (now known as the household appliances manufacturer AEG-Electrolux) was primarily a *generator* of electricity. In 1907 Peter Behrens, perhaps the first industrial designer, was hired as a consultant to find ways to increase demand for electricity during the day. His solution? The first electric kettle, developed for AEG and produced in 1909. That year is also considered by those in the know to be when the first commercially successful electric toaster was launched by the Edison General Electric Company,

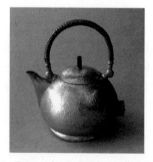

Peter Behrens (1868–1940), electric kettle, nickel-plated brass and rattan, 1909

The Edison General Electric Company
model D-12 toaster

the model D-12. When this toaster hit the shelves, I imagine it would've been regarded as a rarefied luxury, purchased by those early adopters at the forefront of the technological wave. Something like the iPhone is now—though making this comparison will quickly age this book. By the time you read this, the iPhone will of course have been superseded by the super-iPhone or somesuch, just as early toasters were superseded by the dual-side toasting, self-timing pop-up toasters, which in turn will also likely be superseded by as yet undreamt of toasting sophistication (unless, to use Doors front man Jim Morrison's memorable phrase, "the whole shithouse goes up in flames," or people just stop liking toast).

Anyway, at the time of the first toaster's development, the additional convenience it provided would've been a boon. Toast without stoking the coal-fired range? How terribly marvellous! One doesn't even require one's butler! A hundred years on, however, and the electric toaster is mundane and common throughout much of the world. Amongst the jumble of products and services we are now surrounded by, the humble toaster's function seems inconsequential.

Toaster production, however, is no longer inconsequential. The industry that produces them (and all of our other stuff) has grown such that the ability of the natural environment to accommodate it is being strained in a whole variety of ways. Even on a planet-sized scale, its effects are no longer trivial. The contrast in scale between this globe-spanning industry and many of the inconsequential products we use it to make seems a bit absurd—all of this, for toasters?

Are toasters ridiculous? Close up, a desire (for toast) and the fulfilment of that desire are totally reasonable. Perhaps the majority of human endeavour can be reduced to the pursuit of additional modicums of comfort—like being slightly less tired, being slightly less bored, or just an evenly crispy piece of toast—small trifles, to which we quickly become accustomed. This millennia-long striving to better our lot has thus far enabled more people than ever to buy a toaster (amongst other notable achievements). I really appreciate being comfortable and living when and where I do, and I'm also generally quite a fan of technology. But it feels like some things make such a marginal contribution to our lives that we could do without them and not even notice. This begs the question of what goes and what stays, and I can already imagine the arguments over whether hair straighteners are more or less essential than electric shavers. So far we've settled things by simply voting with our wallets, and it seems the clear winner at the ballot box is more rather than less. But what if some of the things we're voting for aren't being entirely candid about their origins? What if much of the cost of making them is hidden from us, or falls unequally on someone else? What if the vote is distorted?

The toaster serves as a symbol, my figurehead for the stuff that we use but is maybe unnecessary, but then again is quite nice to have, but we wouldn't really miss, but is so relatively cheap and easy to get that we might as well have one and throw it away when it breaks or gets dirty or looks old.

So that is "why a toaster."

Well that, and because I really like Douglas Adams: "Left to his own devices he couldn't build a toaster. He could just about make a sandwich and that was it."

This quote is taken from *Mostly Harmless: The Fifth Book in the Increasingly Inaccurately Named Hitchhiker's Guide to the Galaxy Trilogy.*

Our hero, Arthur Dent, a typical man from twentieth-century Earth, is stranded on a planet populated by a technologically primitive people. Arthur expects he'll be able to transform their society with his knowledge of science and modern technology, like digital watches, internal combustion engines, and electric toasters, and thus be acknowledged as a genius and worshipped as an emperor. However, he realises, that without the rest of human society he can't actually make any of it himself. Except, of course, a sandwich, one of which he happens to make himself one afternoon. This never-before-seen advance in eating technology so stuns the villagers that they promptly elevate Arthur to the high office of Sandwich Maker, whose sacred duty it is to hone and research the advanced art of the sandwich.

I read this book when I was about fourteen. The passage must've had a great effect on me to linger in the synapses of my brain only to resurface a decade later as the inspiration for my second-year master's project.

My god. What would I do if I crashed on a strange planet? How would I even make a knife? What Adams draws on—a remarkable lack of knowledge about the basic technologies that underpin our modern existence—is true for most of us today. The idea that modern society divorces people from practical ability is not new, and usually carries negative connotations. Imagine a sci-fi film on the topic: *Toast*. Plot: The dust settles and surviving United Kingdom residents realise that although well versed in the health and safety implications of improper typing ergonomics, they don't actually know how to make anything. How would people toast bread in this post–apocalyptic world?

Is it possible I could avert this disaster by reverse engineering a toaster, examining its constituent parts and materials, and recording my attempt to construct a duplicate from raw materials, using only the tools that might be available in post-crash civilisation?

And that is another reason why I want to build a toaster.

* * *

The Royal School of Mines, Imperial College, London
Senior Common Room
Friday, 7 November 2008 (Lunchtime)

My meeting with Professor Cilliers continues . . .

PROFESSOR CILLIERS: OK. So can you have some
people doing stuff for you, or do you insist on
doing it all yourself?

ME: Well, I want to make it myself...
And how set are you on the materials being
comparable to modern materials?

[Silence... I'm quite set on it.]
Right. Well, if you use metals that are different
they'll be more expensive but much easier to
produce. So iron and steel, everyone uses iron
and steel for everything because they're cheap,
they're produced in such vast quantities. For
you to make iron and steel it's going to be,
err, a real bitch. But if you were to use copper,
well that could be quite feasible because you
don't need high temperatures. That's why we went
through the Bronze Age first, because it's piss
easy to do.

Right.
Well the other thing is... you can say, well,
can I use electricity? Do I have to make that
myself? Can I use acid, do I have to make
that myself? Just how far are you going to the
root of the problem?

Well, I've got these rules...

THE RULES

The rules of the project are all-important. Of course I could make a toaster by going down to the Maplin Electronics shop, buying some Nichrome wire to bend into an element, buying an electric cord and a plug and wiring the whole lot together. Or I could make a toaster by sticking a piece of bread on the end of a stick and holding it over a fire. But that would be cheating…

Rule 1.
My toaster must be like the ones they sell in the shops.
What is a toaster? An object that toasts bread. A fire toasts bread. A fire is not a toaster. Why is a fire not a toaster? A fire is not a toaster because when you ask in a shop for a toaster, they don't sell you a fire. Thus,

> **A.** It must be an electric toaster that plugs into the mains electricity supply.
> **B.** It must be capable of toasting two slices of bread, at the same time, on both sides at once.
> **C.** It must be what is commonly known as "a pop-up toaster."
> **D.** It must toast bread for varying amounts of time.

Of course the ones they sell in the shops come in a wonderful array of shapes and colours (except they don't, being mostly some variant on white or silver, and some kind of rounded cuboid roughly the size of a small terrier dog). They do come in a wonderful array of prices however, from £3.94 to £166.39 ($6.10 to $259.33)—which is quite a price range for a single type of product in the same shop.

Guided by my (evidently misguided) belief that cheapness begets simplicity, I chose as my exemplar toaster the:

Argos Value Range 2-Slice White Toaster
Cat. # 421/9608 £3.94

—

Which includes:
- Coolwall
- Variable browning control
- Mid-cycle cancel
- Cord storage

—

A great value toaster, which embodies the centuries of incremental technological development, rising material wealth, and diverse global supply chains on which modern life depends. A must for any well-appointed kitchen!

It doesn't have a crumb tray, though.

Rule 2.
I must make all the parts of my toaster starting from scratch.

What does from scratch mean? From scratch means making something starting from the very beginning. What does starting from the very beginning mean? Starting from the very beginning means starting with nothing. Oh dear, my mind wanders…

I cycle to some remote woods with a deep lake, dismount my bicycle, and throw it in the lake. Then from my pocket I take a box of matches containing a single match, and a small bottle of petrol. I take off my shoes and all my clothes, pile them in a heap on the

ground, pour on the petrol, carefully light my single match, and . . . I'm naked in the woods and I'm making a toaster, *from scratch*. As anyone who's paid the slightest attention to Ray Mears's BBC series *Extreme Survival* knows, the first thing to do in a survival situation is find shelter and water. Then food. Once those essentials are sorted out, I can begin the long process of making clothes and the first tools that eventually will lead to the creation of my electric toaster.

But perhaps even this isn't enough—the apple pie recipe of noted astrophysicist and archetypal 1980s science documentary presenter Dr. Carl Sagan rings in my ears: "If you wish to make an apple pie from scratch, you must first invent the universe." The enormity of my task freezes me in my tracks.

Luckily, my naked contemplation of Dr. Sagan is interrupted by some startled ramblers, who report me to the local constabulary. I'm apprehended and receive a caution for breaching the peace and a small fine for contravening bylaws by starting a fire in a national park. They do, however, give me a lift in their police car back to the real world...

I'm making a toaster from scratch, and I live in London, in the United Kingdom, in the twenty-first century. I still want to sleep in my own bed, watch TV occasionally, and use the web to find stuff out, so I decide that from scratch means from the basic ingredients; that is, from the materials as they come out of the ground.

Rule 3.

I will make my toaster on a domestic scale.
I must make my toaster myself using tools that aren't fundamentally different from those that were around before the Industrial Revolution. This is because if I went and collected a bunch of ore from a mine, took it along the road to a smelting plant and had it smelted, then took the refined metal to a wire maker to have it made into wire . . . well, I wouldn't be making a toaster myself, would I? I'd be paying other people to use their very expensive and very complicated tools to make me a toaster. Besides, I don't have the money.

I want to make my toaster myself, on my own. This means I'm making an object that's usually produced in huge numbers in huge factories, singularly: a domestic object made on a domestic scale.

Thus, I decide:

A. Travelling overland is allowed because cars are just modern versions of horses. Flying is not allowed because human flight is a complete break from the past, with no pretechnological equivalent.
B. Using some domestic hand tools is allowed, even, say, an electric drill, because it just replicates a manual drill but is a lot quicker. Of course, using 3D-design software and a robotic milling machine is not.

So, with my rules logically infallible and set in stone I can begin.

* * *

The Royal School of Mines, Imperial College, London
Senior Common Room
Friday, 7 November 2008 (Lunchtime)

Professor Cilliers continues to ask his difficult questions...

PROFESSOR CILLIERS: When you look at what the old miners did, they smelted rock, but they started with a very high-grade ore. High-grade ore just doesn't exist anymore. You've got to understand that typical ores have half a percent copper in them. So say we want a kilogramme of metal, we've got to treat a tonne of ore. Even for small-scale stuff you need quite a lot of rock. Can we find a lump of ore that has enough copper in it... there are mines that are rich in copper... if you go to Finland. The north of Finland. It'll take you a week. So you get the copper, and you plate it out into sheets and hammer it into the shape for the casing.

ME: The toaster I had in mind has a plastic casing.

And you need plastic for what?

To make it look like a toaster.

Well, I'm a metal man.

Well, the internal bits are metal.

The problem with plastic is that it's from oil. That technology is quite hard. That's why we didn't go through the Plastic Age before the Bronze Age, you know.

Right. I see.

If you look at those really groovy toasters,
the handle comes out... um...

 Dualit!

There we go, yeah. See, if you make a Dualit one,
you need very little plastic. Lots of metal.

 I sort of decided to model my toaster on
 a cheap one from Argos. They have a plastic
 casing, you see.

OK, so, you need a casing of some kind. Then you
need an element.

 Toaster elements I heard, or actually read,
 are made out of an alloy of chromium and
 nickel. And I looked around and I think
 there's a nickel mine in Siberia...

The nearest high-grade mine is probably in Turkey.
But then you'll need a tonne, so... Anyway, then
you need to get electricity to the element.

 Copper wires.

And you need something to wrap the element around
so it doesn't catch fire, basically.

 I think in toasters they have some sort of
 mineral or something.

Yes, it's mica. Well it used to be, I don't know
if they still use mica or some modern synthetic
substitute now.

Steel

Steel

"If I can make steel," I tell myself, "then the project is a goer." I know that steel comes from iron. I have vague memories from school of terms like "pig iron," "blast furnace," and "slag."

Going by annual production figures (given in millions of tonnes per year), the steel in my Value toaster was most likely refined in China, from iron ore mined in Australia, Brazil, or possibly (but not certainly) China also. Unfortunately, I don't live in any of those places. The closest iron mine I can find to London is in the Forest of Dean, just on the English side of the border with South Wales. It's 139 miles away. Google says that I could walk there in forty-six hours if I didn't stop to eat or sleep. Luckily for me, some people had previously laid a railway line most of the way there.

I phone up the mine to arrange my visit. The man I speak to, Ray Wright, is rather nonplussed when I explain that I'm trying to make a toaster so would like

London to Clearwell Caves, 139 miles

to come and mine some iron ore. Quite surprisingly, he doesn't just hang up, but agrees to my visiting his mine the next day.

Iron for swords and ploughshares had been mined at Clearwell since the Iron Age. Up until it closed at the end of World War II, the mine had an output of thousands of tonnes a week. Ray had been a miner there when it was still going but now, along with his son Jonathan, runs Clearwell Caves and Ancient Iron Mine as a visitor attraction (voted Gloucestershire's Family Attraction of the Year for 2003).

Ray Wright, freeminer at Clearwell Caves and Ancient Iron Mine

We arrive at the mine in the late afternoon (we being me and my good friend Simon, whom I'd dragged along to help). It soon becomes clear, however, that when I'd spoken to Ray on the phone and asked if I could come and mine some iron ore "because I'm trying to make a toaster," Ray had thought I'd said, "because I'm trying to make a poster," and so had assumed I'd just want to take a photo or something. To be fair to Ray, the poster scenario does sound more plausible.

In any case, my notion of simply hacking a few bits of crumbly rock from the wall of a tunnel is quickly stripped away (I had, in fact, decided against bringing my pickaxe with me because I'd assumed one would be provided). As Ray makes clear, mining is not something to be taken lightly—pneumatic drills and perhaps explosives would be needed. It is also not a half-day activity, because simply to get to the working face of the mine requires a long ride in an underground train.

Crestfallen, I begin to think my journey was wasted, and I'll have to return to London with my suitcase still empty. After some embarrassingly persistent pleading on my part, Ray agrees to take us part way into the mine to see if we can find any ore lying about.

The walk through the mine is a fairly surreal experience because they have the Christmas decorations up. There's even a stuffed reindeer and one of Ray's assistants dressed as Father Christmas. I ask Ray what he thinks about the mine as a visitor attraction.

Ray is not a fan of the huge-scale mining operations seen in Australia and South America—the ones that made mining uneconomical on the scale possible at Clearwell. He is of the view that work on such a scale reduces humans to ants—no one understanding what their small part of the puzzle actually means. Or, as Karl Marx put it in his *Economic and Philosophic Manuscripts* (1844):

> He does not fulfill himself in his work but denies himself, has a feeling of misery rather than well-being, does not develop freely his mental and physical energies but is physically exhausted and mentally debased. The worker, therefore, feels himself at home only during his leisure time, whereas at work he feels homeless. His work is not voluntary but imposed, forced labour. It is not the satisfaction of a need, but only a means for satisfying other needs.

Ray still does some mining at his mine though, for grammes, rather than tonnes, of a substance called iron ochre. This is basically rusty iron powder, which is used as a pigment in lipstick and artists' oil paints.

I think Ray thought it a good idea to keep at least some mining going (even if just to make lipstick) so as not to end the history of mining that stretches back to a time when most residents of these islands lived in hovels (or indeed in the caves at Clearwell themselves). I wonder if

Ray feels there's something slightly ignominious about his mine having been turned into a tourist attraction.

What would have to change for the iron at Clearwell to be worth mining again? Probably nothing short of total global economic collapse. According to Ray, this is prophesied to happen in 2012 when the Mayan calendar runs out of numbers. I think he is holding out hope that Clearwell will become a working mine again sooner rather than later.

* * *

So, I didn't actually mine the iron ore myself; Ray did, some years previously. He took it from one of the displays at the end of the tour. I got it home, though, in a suitcase whose wheels quickly disintegrated, and it was heavy, forty kilogrammes heavy.

With the fraction of iron in the rock at about 40 percent according to Ray, and assuming I manage to extract, say, 50 percent of that, I should be left with eight thousand grammes of iron to play with. More than enough for my toaster. But first I have to somehow get the iron out.

This rock doesn't look anything like metal, it just looks like rock—maybe rock from Mars but still just rock. The task I face is to separate the atoms of iron from the atoms that make up the rest of the rock. Like getting blood out of a stone, but blood that is particularly iron rich.

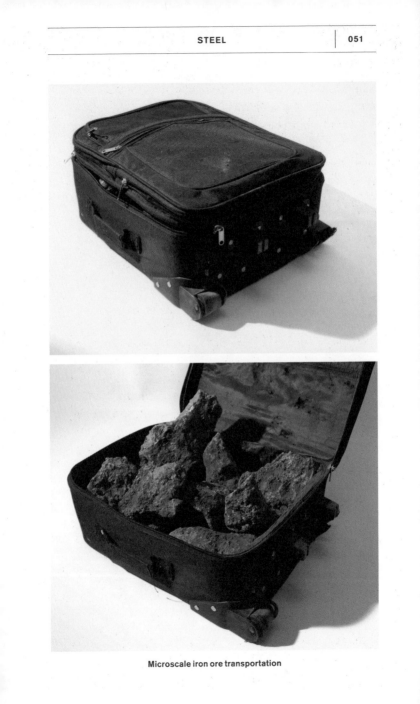

Microscale iron ore transportation

The Imperial College library has a whole metallurgy section. Leafing through undergraduate textbooks on the subject, such as the classic *Principles of Extractive Metallurgy*, I realise that if you actually want to do extractive metallurgy, modern books on its principles are not what you need. Though well illustrated with flow charts explaining complex industrial processes and equations showing the reactions involved—all very useful if you're going to work at Tata Steel or somesuch— nowhere can I find a section on doing it yourself.

Imperial College library, metallurgy section

The Science Museum's history of science library is where I find *De re metallica*. It was written by Georgii Agricolae in the sixteenth century, in Latin, and translated by Herbert Clark Hoover and his wife, Lou, before he was elected thirty-first president of the United States. Dedicated to "the most illustrious and most mighty dukes" of Europe, it was the first book on metallurgy ever written—well, in the West at least (in China several books describing metallurgical techniques had already been published). It chronicles the diverse ways in which ores were mined and their metals extracted throughout the then-known world. Despite being written almost five hundred years ago,

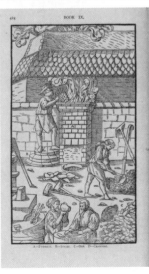

Georgii Agricolae, *De re metallica* (1556), translated from the first Latin edition by Herbert Clark Hoover and Lou Henry Hoover, published by the *Mining Magazine* (London 1912)

it's actually more useful for my purposes than a modern textbook. It strikes me that a methodology from the sixteenth century is about the level of technology we can manage when we're working alone. In a sense, the smaller the scale on which you want to work, the farther back in history you need to go. Working on a domestic scale, as far as metallurgy is concerned, requires going back centuries.

The woodcut diagrams of the various "bloomery" furnaces are fantastic. Even the concept of a diagram itself seems to be under development: While labels are mostly confined to relevant objects such as a "set of bellows" or "crushed ore," as you'd expect, sometimes odd things like a "sleeping dog" or "some steps" or "peasants drinking mead" are labelled too. Of course, the materials I have on hand differ from those commonly available in the sixteenth century. Today it's much easier to get hold of cheap hair dryers than a set of bellows made of wood and leather. So that's what I use, hair dryers, along with an ornamental chimney pot from my mother's garden, a dustbin, some Vermiculite loose-fill loft insulation, half a door from a filing cabinet, a bit of tile, and some clay.

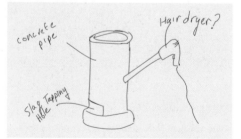

A primitive diagram of my modern, primitive furnace

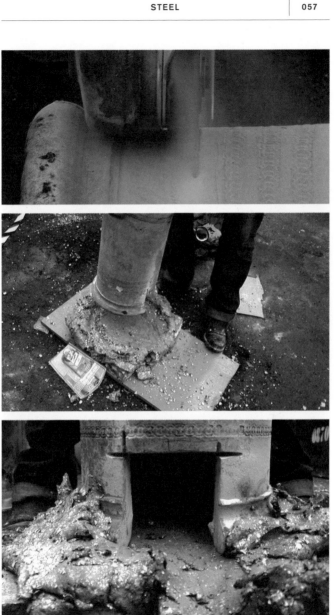

Building the furnace

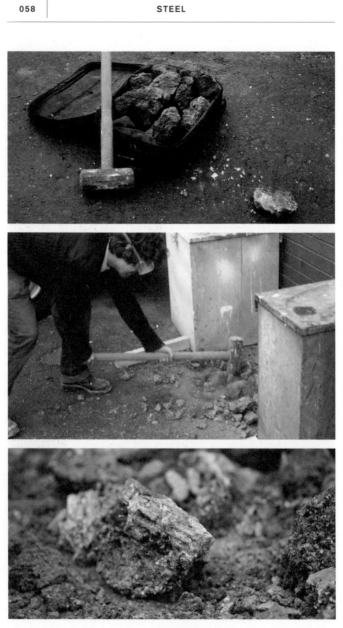

Crushing the ore

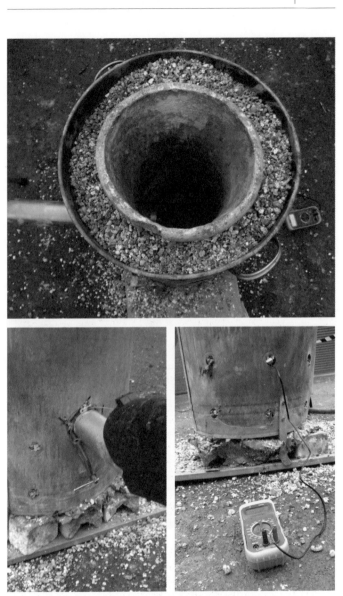

A leaf blower and electric temperature probe:
modern equivalents of a bellows and judgement borne of experience

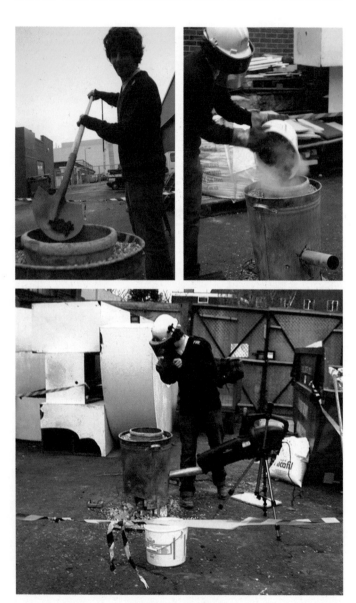

Getting the fire going

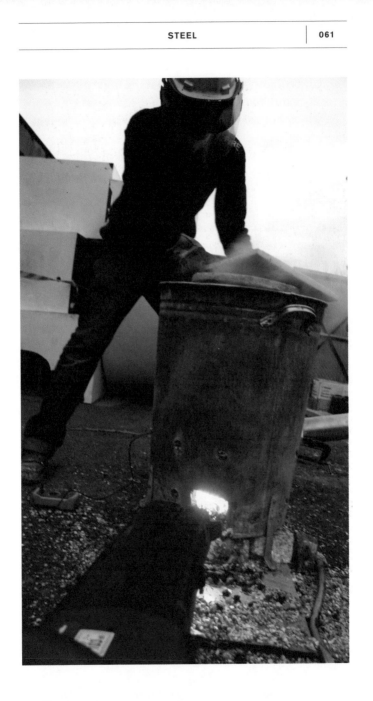

Unfortunately, it turns out that the hair dryers have a safety cutoff to prevent them from getting dangerously hot, which they soon do. Luckily, I have an electric leaf blower on hand also.

There is no way of knowing whether the thing is actually working or not. All I can do is keep on feeding it with fuel and my smashed-up ore, and hope. My temperature probe catches fire about halfway through the process. Its last reading is 1206 degrees Celsius. This theoretically means the furnace is hot enough to be working.

* * *

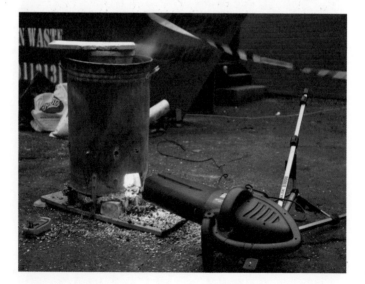

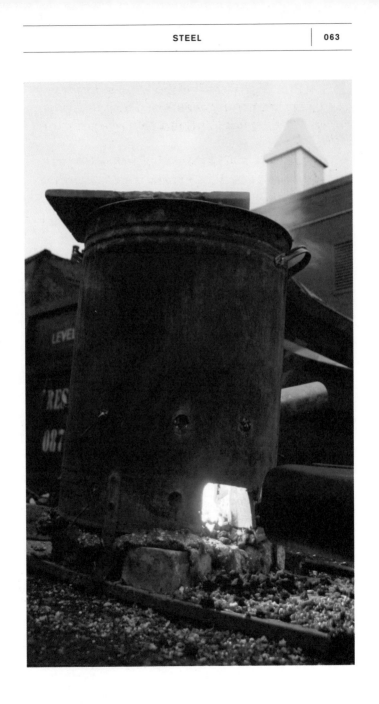

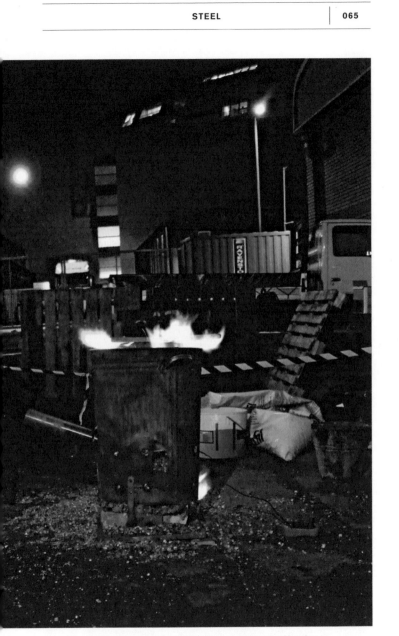

Smelting iron late at night in a car park in central London

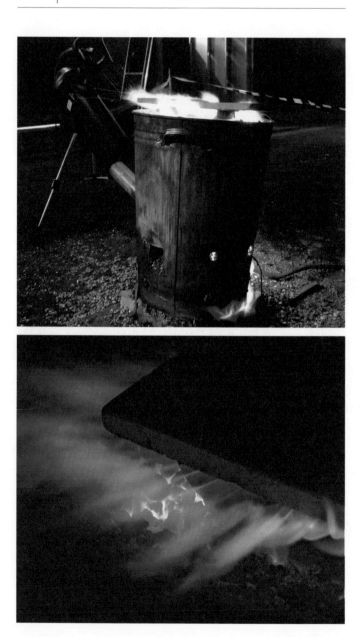

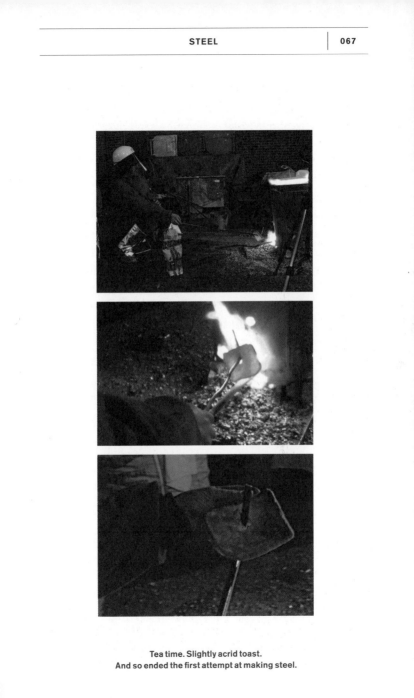

Tea time. Slightly acrid toast.
And so ended the first attempt at making steel.

I had been aiming to make what's called a "bloom" of iron—so called because it's meant to look like the bloom of a cabbage (to be honest, I wasn't even aware that cabbages had blooms). Late that night, after the last of the fuel had burned away, I poked through the furnace with a stick and pulled out a bobbly black mass of something heavy. Squinting through the fumes, and wanting to believe in success, I was convinced that what I had was indeed a bloom of iron.

Once my bloom was cool enough to handle, I tested it with a magnet. It was magnetic. With trepidation I brought it to my tongue to taste it—it tasted metallic! It perhaps didn't look shiny in the way we expect metals to be, but I reasoned that this must be what "old style" metal looks like—sort of "organic" metal. If it's (weakly) magnetic, tastes like metal, and looks (a bit) like metal, well, it must be metal! After actually bragging of my success for a few days (even demonstrating the magnetism of my incredible homemade metal to amazed friends and onlookers in several pubs), I finally got around to beginning to work a piece of my bloom into a toaster component. What really mattered about the metal I'd made was that it was malleable—that I could shape it into the bars for the grill and the flat sheets for the structure. Using a blowtorch, I heated it up until it glowed bright red, and hit it gently with a hammer. My "iron" shattered on impact, along with my dream of making a toaster.

I had failed the first hurdle. My project lay in ruins, as did my furnace. The faux-antique ornamental chimney pot I'd used for my furnace had literally melted itself with the heat and burst apart, and bits of the Vermiculite loft insulation I'd packed around it

had fused together. According to the blurb on the Vermiculite packet, this didn't happen below 1200 degrees Celsius. I'd got up to a hot enough temperature, but what had gone wrong?

With the benefit of hindsight, and a little more extensive research, I can see that my first, and quite fundamental, mistake was in my choice of fuel. In early furnaces, charcoal was used as a fuel. It was replaced by coke during the period we now call the Industrial Revolution, and coke is still what's used today. I had sort of assumed that because coke is used in modern furnaces, it must be generally superior as a fuel, and thus I decided to use coke (of which—perhaps not incidentally—I had a free and ready supply). However, coke had replaced charcoal not because it was better, but because trees for making charcoal were running out. Demand for iron had grown so much that basically the rate at which trees grow had become the limiting factor in the supply of charcoal, which limited the supply of iron. Because of the limited charcoal supply, there was therefore a lot of incentive for someone to work out how to use the abundant fossilised trees (coal), which could simply be dug up from the ground, rather than waiting for a load of new trees to grow.

The trouble was that even coke—coal that has been pre-roasted to remove impurities—still contains a lot of sulphur, phosphorous, and other impurities. Because the iron ore and fuel are mixed together and in direct contact in the furnace, the iron will absorb impurities from the fuel.

Due to these impurities, iron produced with coke is hard and brittle and not actually useful for making anything. It's known as pig iron, apparently not with

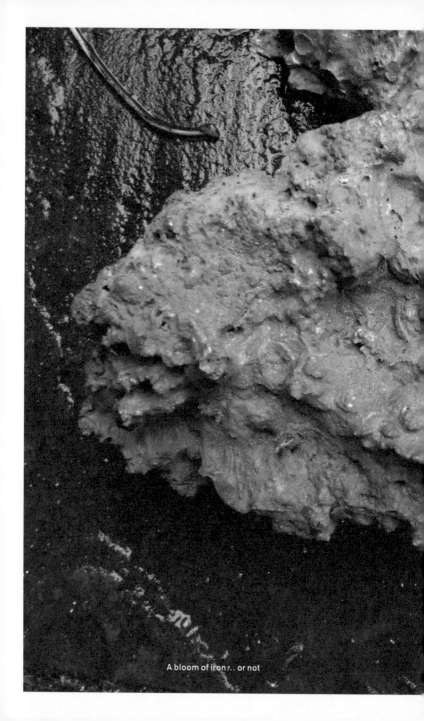
A bloom of iron... or not

reference to the much maligned hygiene habits of pigs, but because it was once common practice to pour the freshly smelted molten iron into a mould which resembled a sow suckling her piglets—a central feeder channel with smaller ingots coming off on either side. It seems rather an odd choice of visual metaphor to me, but when the term was coined, I suppose suckling pigs (and blooms of cabbages) would've been a rather more day-to-day sight.

To actually get useful material from pig iron involves a whole additional process to reduce the amounts of impurities. It's not a trivial thing to do, the various methods that were eventually developed led to the Industrial Revolution and the modern world. They all basically involve exposing molten pig iron to oxygen, to burn off the impurities that will burn (like phosphorous), or adding other elements to bind with the impurities that won't burn. Back when the method was first developed, the oxygen exposure came from stirring a puddle of molten iron in air; nowadays they use a water-cooled lance to inject pure oxygen into house-sized crucibles of molten iron, but the principles are the same.

Depending on how you remove the impurities, you can get three main flavours from your iron: cast iron, wrought iron, or steel. We're so used to thinking of materials as sharply distinct from one another, it's easy to forget that in the messiness of the real world pretty much everything is mixed together. Before chemistry enabled a theoretical definition of elemental iron, what "iron" was, what you could use it for, and how it could be made were incrementally eked out.

If you're going to be hitting your iron with a hammer, you need wrought iron, or maybe steel. It is possible to

make these without going through the intermediate step of making pig iron, if you have charcoal and the right knowledge and skill. I only had enthusiasm, which is a poor substitute when dealing with inanimate materials. At the time I wasn't aware of this fact of life, so I was hoping that the "bloom" I'd fished out of my furnace was at least wrought iron, or even that I'd got lucky and hit the carbon sweet spot and managed to produce steel.

My first mistake was caused by the wrong-headed assumption that a newer process was necessarily superior to an older one. Coke is only a better fuel than charcoal in a situation where trees are limited compared to the amount of iron and steel you need to make. Charcoal is better if the supply of trees is plentiful compared to the amount of iron you're making. Trying to make eight thousand grammes of iron definitely falls into the second situation.

Cleverly solving the tree shortage by working out how to use fossilised trees has led, hundreds of years later, to an atmosphere shortage. There are still plenty of fossilised trees left to burn; the problem is we want to burn so many that the atmosphere's ability to deal with all that carbon is being tested. Hopefully there's incentive enough (financial or otherwise) to cleverly negotiate this new shortage too.

My second wrong-headed assumption was that because iron smelting is an old technique, it must be pretty simple for a modern, educated guy like me to master. The iron in iron ore is present as iron oxide: iron atoms bound with oxygen atoms. Oxygen and iron have quite an affinity for bonding; iron oxide is also called rust and, as we all know, things rust without us having to do anything to them. So, to rip the oxygen

and iron apart requires a lot of energy, which is what you're supplying by taking your furnace up to 1200 degrees Celsius. But to help things along, you also need to supply something more attractive than iron for the oxygen to bond with, something "reducing," like carbon monoxide. Carbon monoxide can be made by incompletely oxidising things containing carbon—say, by burning fossilised trees with only a limited supply of oxygen. For example, if there's not enough air getting into a household boiler, there won't be enough oxygen for all the gas to grab two oxygen atoms each and form carbon dioxide—some of it will be left with one oxygen atom as carbon monoxide. If this happens in your household boiler, you could suffer from headaches, hallucinations (carbon monoxide poisoning has been implicated as the cause of many "haunted" houses), and, in tragic cases, death. In a furnace, however, carbon monoxide can help reduce the iron oxide to iron.

More air blowing through the furnace means more oxygen, the coke burning more completely and more fiercely, which means more heat. However, the coke burning more completely also means that less carbon monoxide is formed, which means the oxygen part of the iron oxide has less reason to leave the iron. So, not enough air and the furnace won't get hot enough, but too much air and, though it'll get hot, the atmosphere inside the furnace won't be right.

I'd had my leaf blower set at nearly full blast most of the time, but I had no way of judging if it was providing too much air, or too little. Furthermore, this balancing act means that there was no guarantee I'd judge it right if I attempted to smelt again. In fact, looking on the internet at other people's iron-smelting

attempts, I found that success was far from assured, with the majority of attempts failing to produce iron.

So, my "bloom" of "iron" could be a lump of pig iron with too many impurities in it because I'd used coke as a fuel instead of charcoal. Or maybe, if I'd had too much air going through my furnace, it could still be iron oxide. Or perhaps it could be some kind of mixed-up combination. In the first case I needed to melt it again in the presence of oxygen to try and burn off excess carbon and other impurities. In the second case I needed to re-smelt it but make sure the supply of oxygen was limited. In the third case, well, I had no idea. Each of the options required building another furnace, but with no guarantee that I'd manage to make it work the second time, or the third, fourth, or subsequent times after that.

After a few days of quite severe moping, I picked myself up, and in the long tradition of humans wishing to avoid hard work, started trying to think of ways out of my predicament. Ovens are more convenient than fires, and microwaves are more convenient than ovens. An oven goes up to only about 300 degrees Celsius, or "gas mark 9," but what about a microwave? It doesn't have a temperature gauge, but a time gauge. What would an hour in a microwave do to a piece of pig iron, or a piece of semi-refined iron ore? I find a patent online, granted in 2001 for the smelting of iron oxides using microwave energy. Detailed in the patent was the use of an industrial microwave. I didn't have access to one of those, but what about the kitchen microwave?

But hold on. I'd said in my rules that I wasn't going to use tools "fundamentally different" from those that existed in a pretechnological age.

Huang et al., United States Patent No.: US 6,277,168 B1 (2001)

Is a microwave anything more than a glorified fire? Is it fundamentally different?

Deep down I knew I thought it was. Microwaves heat things by spinning molecules rapidly back and forth with electromagnetic waves generated by a magnetron. Or so the saying goes. Fires cook stuff by transferring the energy released from oxidising carbon via electromagnetic waves and agitated molecules bumping into less agitated ones. To be honest, both methods of heating

sound equally exotic when described in the language of science. From a practical point of view, however, to make a fire I can just rub two sticks together.[†] To make a microwave, well, first I need some iron...

Oh, what the hell, this opportunity to taste the forbidden fruit of putting metal in a microwave is too good to pass up. Also, the patent authors claim that microwave smelting of iron produces only half the amount of harmful emissions as smelting using coke. I decide that it was a stupid rule anyway.

After some not-so-careful experimentation that necessitated replacing my mother's microwave, followed by some rather more careful experimentation, I manage to make a blob of iron about as big as a ten pence coin. A blob of iron that when hit with a hammer on a borrowed anvil doesn't shatter, but squishes as it should!

The recipe is as follows: Stuff the inside of the microwave with ceramic wool insulation, leaving a small cavity near the wave guide. Put a small piece of pig iron/half-smelted iron ore in a ceramic dish along with a bit of charcoal, cover, and place in the cavity. Cook on high for around twenty-five minutes. To produce enough iron for one toaster, repeat the process ad nauseam.

* * *

[†] I have since tried to start a fire by rubbing two sticks together. It is by no means an easy feat.

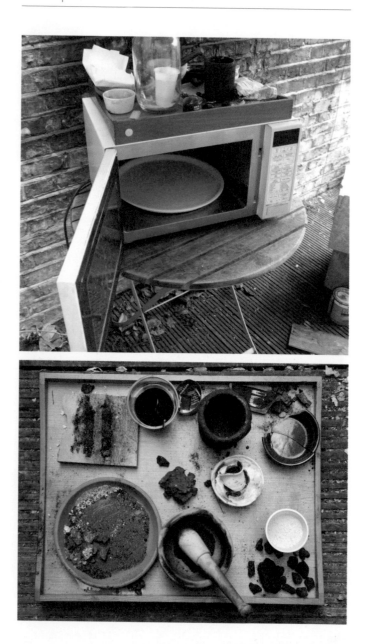

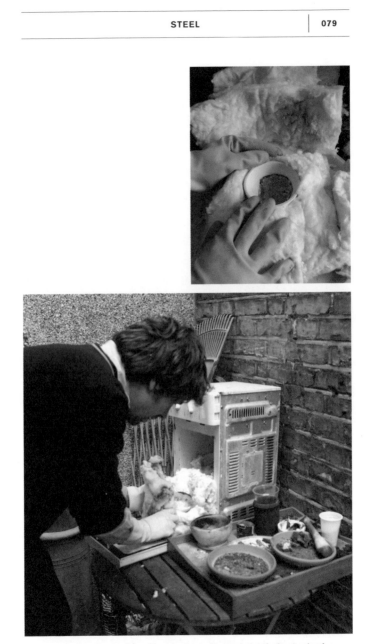

Insulating the crucible with ceramic wool to maximise the heat gained

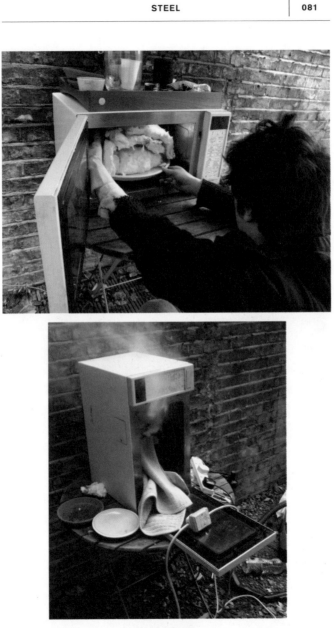

An early failure

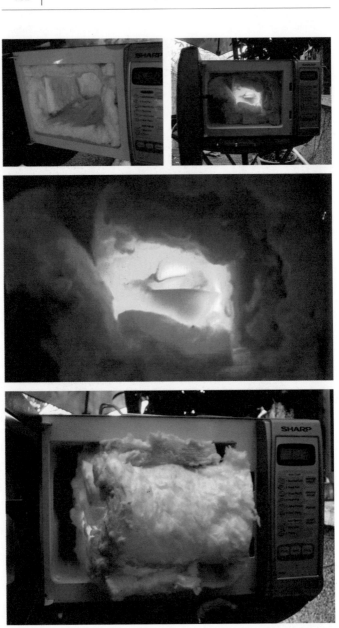

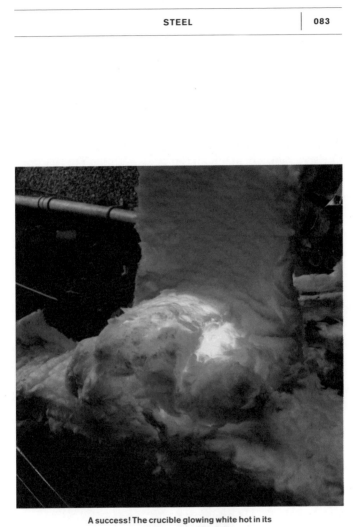

A success! The crucible glowing white hot in its
partially unwrapped insulation

On the way home after my initial success that night, I'm rather overcome by the amount of highly pure metal casually lying around in the urban environment—the street lamps, the drain covers, the railings to discourage people from crossing the road in the wrong place—all massive hunks of steel or iron or something. There are tonnes of metal all around me, and I was overjoyed to have smelted a small piece to a purity that would be rejected by any manufacturer.

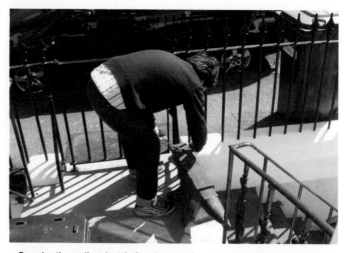

Securing the anvil against theft as it was too heavy to carry into the back garden

Testing my piece of microwave-smelted iron

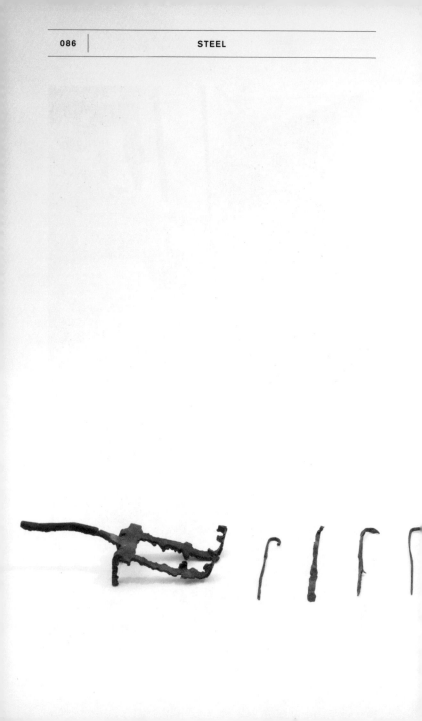

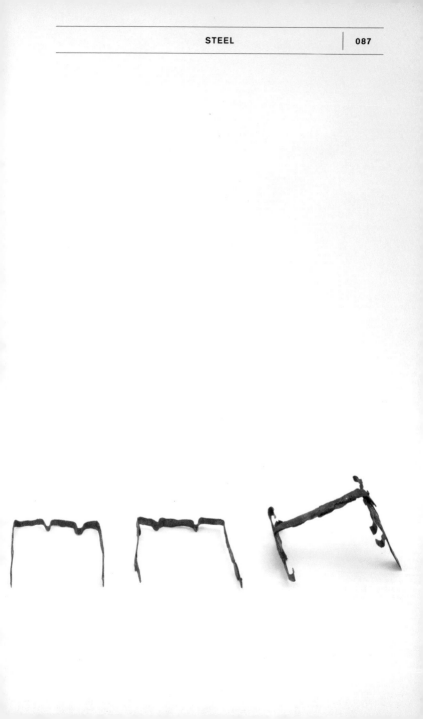

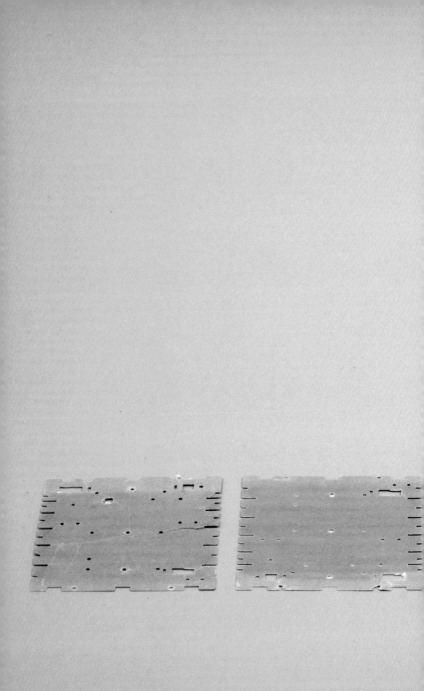

Mica

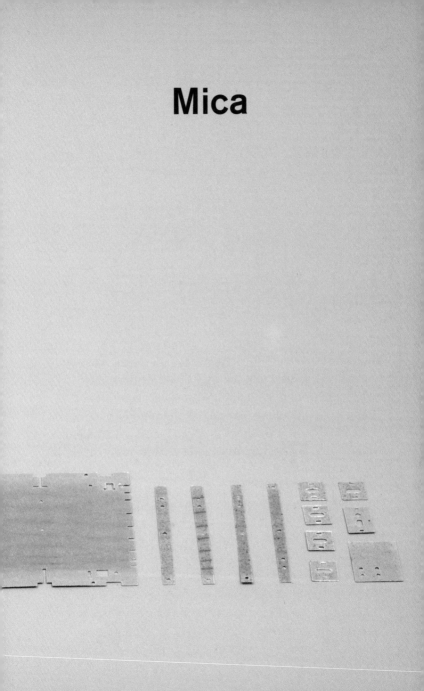

Mica

In a toaster, mica is the silvery-grey sheet that looks a bit like cardboard that the wire heating element is wrapped around. It's a naturally occurring mineral that happens to be a good thermal insulator and a good electrical insulator. These properties make it an ideal material to support a wire made very hot by electricity passing through it.

In 2006, 310,000 tonnes of mica were extracted from the ground globally, enough by my reckoning for about 4,000,000,000,000 (four-thousand billion) toasters, or five hundred toasters per year for every person alive. I conclude, therefore, that there must be other uses for mica. For my purposes, I just need a couple of small "sheets," or whatever the standard unit of measurement of mica is. The mica mines of China are the most productive in the world, but unfortunately (or, on the other hand, fortunately), I don't live anywhere near the mica mines of China.

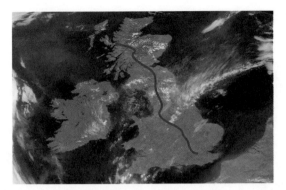

London to the Knoydart Peninsula, 518 miles

Knoydart is a small peninsula on the west coast of Scotland, near the isles of Muck, Eigg, and Rum. Though it's not an island itself, no roads go there: access is either on foot over mountains (about a day's hike) or by boat. As well as the post office, the primary school, and the "most isolated pub on mainland Britain," there is, or was, a mica mine.

The mine was used during World War II when Britain's mica mines in India were unavailable. I'm told the mica was used to make windows in Spitfires (the fighter plane that won the Battle of Britain against the German Luftwaffe), kerosene lamps, and something in radios. In any case, the mine's inaccessibility meant it was economical to use only during a war, so it was abandoned soon after 1945.

The sleeper train from London's Euston Station to Fort William, Scotland, takes sixteen hours to travel the 475 miles. This is partly because it goes slowly so you can get a good night's sleep. The train from Fort William to Mallaig takes two hours to cover the 37 miles of track. It was voted Top Railway Journey in the World 2009 by

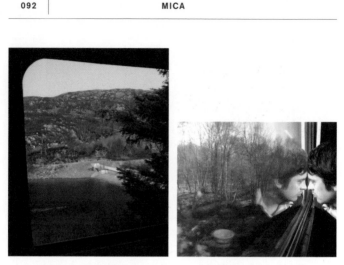

Loch Treig, or another loch Waking up to the highlands

The boat from Mallaig to Knoydart

Wanderlust magazine and crosses a viaduct featured
in the Harry Potter films. The boat from Mallaig to
Knoydart takes forty-five minutes and runs on Mondays,
Wednesdays, and Fridays.

After twenty-four hours of travelling, Simon and
I step off the boat at Inverie, a hamlet on the Knoydart
Peninsula. At the risk of descending further into
travelogue, the landscape is really rather stunning.
Oh, what the hell:

Who needs Canada or Siberia when Scotland can offer such intense drama in a single vista? Knoydart clambers out of the Atlantic gently at first, in a sequence of low hills wrinkled with antiquity, where deer roam. The peninsula's capital—population possibly up to eighty—is Inverie, a huddle of houses beneath some muscular fells. But beyond, dusted with snow even in a mild mid-March, stands the reason Knoydart is the last frontier: mighty mountains rippling away into the mist.[†]

The problem Simon and I face is that we don't actually know how to get to the mica mine. We were meant to meet a chap who'd been there before in Fort William, but he was too busy with his IT business to make it. He'd e-mailed me the coordinates, which I'd saved in Google maps to be recalled later on my iPhone. Unfortunately, it turns out the bloody thing needs to have reception for the GPS to work, and the highlands of Scotland, unlike Mount Everest, remain without mobile coverage.

[†] Says Simon Calder from the *Saturday Independent* travel supplement.

Luckily, the evening we arrive, local residents are having some sort of wicker man–style ritualistic bonfire. We get chatting with a very drunk man, who tells us he's a stalker (stalker, as in hunting deer, not hunting celebrities). After Simon and I join him for a frankly unwise volume of whisky, he draws a line on our map that, he assures us, we can follow right to the mine.

* * *

Very occasionally, a wave of realisation hits me, that I really need to be sensible because I've got myself into a situation where I could get into some serious, potentially fatal difficulties. This is one of those times.

Walking since dawn, we've trekked round the mountainside, attempting to follow the shaky Biro line drawn on our map the night before. It's now well past noon, meaning the sun is sinking, and we're up high and we haven't found the mine. We don't even really know where we are anymore. Having both been born and raised in London, following a map without roads is not familiar to us. Things like deciding whether something

is a stream and therefore shown on the map, or merely a long puddle don't come to us naturally (we work this out after diligently following several long puddles). The major concern is that if we don't turn around and head back soon we will face the steep and rocky descent in the dark. This would not be a good idea, as the only lights we've brought with us are a free torch app on my iPhone (it turns the screen on white) and a promotional pen that lights up, which Simon got at work.

However, I've got this quite extreme desire to not just stop and turn back with nothing. The desire is so strong as to be a sort of siren call, drawing us on just a

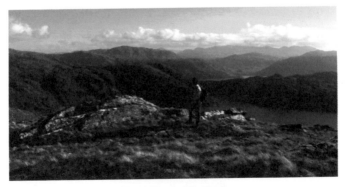

The highlands of Scotland

little bit farther. The mountainside is strange in that every outcrop promises a clear view to survey the landscape for miney-looking sites, only for there to be another outcrop blocking the view just a bit farther on, which actually looks like an even more promising vantage point. Though I'm aware that each metre we walk away from civilisation is actually committing to walking two, because we'll have to retrace our steps at some point, and the sun is sinking lower in the sky, I really, really don't want to turn around empty handed.

After many false horizons, we decide it really is time to turn back. It's incredibly frustrating because we must be so close…we'll just have a look round there and…! We happen across some glinting flakes of what must be mica. The lack of rusting equipment means we haven't found the actual mine workings, but that doesn't matter. Searching around, we see bigger bits emerging from rocks higher up.

Climbing up the rock face, I use my penknife to hack off some of this strange transparent mineral, which almost seems like it's growing out of the surrounding rock. It does indeed come in sheets, which you can peel apart to minuscule thicknesses. I collect enough to split into the three slightly-larger-than-a-slice-of-bread-sized sheets around which I'll wrap the heating element wire when I've made it. Slipping them between the pages of my notebook for safekeeping, we finally turn back. The sunset as we eventually descend is rather spectacular, with Simon's promotional pen only coming out at the bottom, to guide us to the most isolated pub in mainland Britain for a few pints and banter with the locals (though the bartender is [un]surprisingly from Australia).

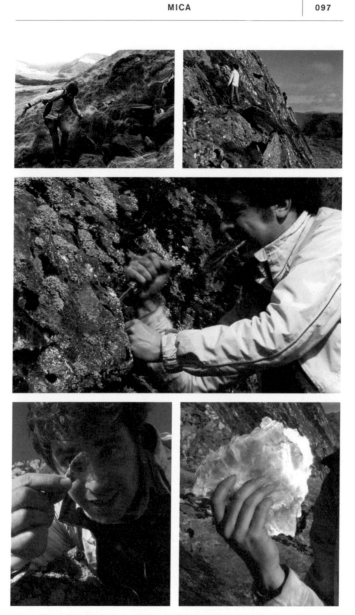

We can't find the mine . . . but we find mica. Hacking the mica from the
rock face with a penknife works surprisingly well.

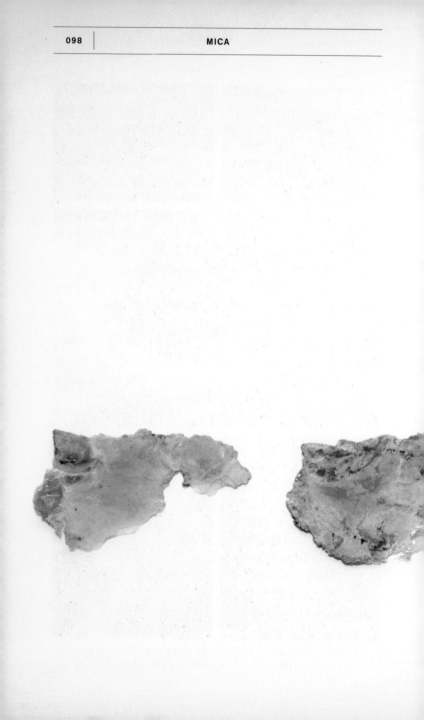

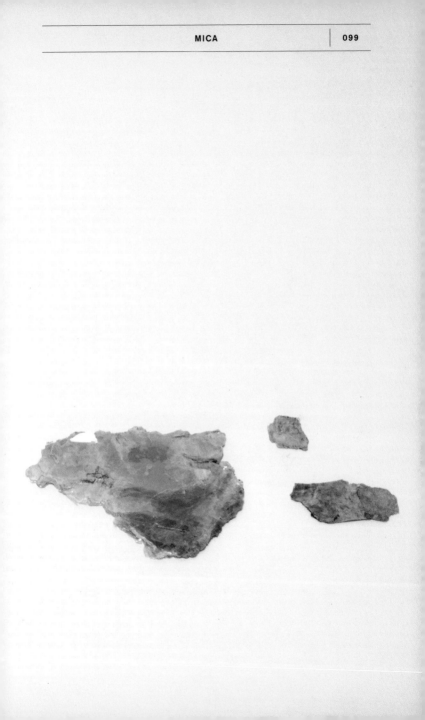

Plastic

Plastic

A plastic case is the defining feature of mass-produced consumer goods. In my eyes it's what makes a toaster, an Argos *Value* toaster. A smooth, shiny case to hide the mess of components inside.

The plastics that we know and love—polyethylene, polypropylene, high density polypropylene, polyethylene terephthalate, polybutylene terephthalate, and acrylonitrile butadiene styrene (to name but a few of our firm favourites)—are all derived from fossilised trees: oil or natural gas. The particular plastic that many appliances are made from is polypropylene, and as its name suggests it's a relatively simple one, so that's the one I'm going to go for.

My GCSE in double science (an exam we take when we're sixteen years old in England) finally comes into its own (I got an A in case you were wondering—thank you, Mr. Dibsdall).

When crude oil is sucked out of the ground, it's a mixture of hundreds of different types of hydrocarbon molecules—carbon atoms joined in chains of various lengths with hydrogen atoms sprouting off. The size of these molecules range from extremely short (just a handful of atoms) to molecules with perhaps thirty carbon atoms in them. The job of an oil refinery is to separate the different sizes of molecules. A mixture of just the larger, heavier molecules is a viscous sludge known as asphalt and used to make roads. The midsized molecules, like hexane (six carbon atoms) and octane (eight), make up much of the liquid that we call petrol.

As crude oil bubbles to the surface, the smallest molecules in the mixture are things like methane, ethane and propane, and ethylene and propylene. They're so small (one or two carbon atoms long) that they're gasses at normal temperature and pressure. This could pose a problem for me because it's propylene that I need.

Also, only a fraction of crude oil is propylene, so I'd need to collect rather a lot to make a decent amount of plastic. However, using a process called cracking, the larger molecules can be split apart to make more of the smaller molecules that I'm after. And then, using a process called supercracking, smaller molecules like methane can be joined together to get even more of the propylene I need. So, once I get my crude, the problem I face will be how to separate off just the type of molecule I want—propylene—and then how to crack as much as possible of the rest into more of it.

Once I've got my propylene gas I need to turn it into solid polypropylene plastic. This happens when at least a thousand of the small propylene molecules link

Molecules from Oil, Charts 1 & 5b, Shell Education Service (1986)

together in a chain, giving you a giant sticky molecule of polypropylene. Millions of these molecules all twisted round each other are what we see when we look at that shiny plastic case.

To get the propylene molecules to join together (polymerise) you need to cause a chain reaction in the gas. To do this one must heat the propylene to about 100 degrees Celsius while also pressurising it to about 200 pounds per square inch (psi)—about thirteen times atmospheric pressure. To start the chain reaction going, you need an initiator of "free radicals"—these are single electrons that react with (or oxidise) just about everything (including the molecules in our cells, which is why those of us who want to live forever should eat plenty of antioxidant containing face cream). Free radicals could be provided by some UV rays, or some hot hydrogen peroxide. You also need a special catalyst to keep the polymerisation regular.

To get the ball rolling, I buy a pressure cooker from eBay from a nice chap who brought it in his luggage all the way from India. Unfortunately, he didn't bring the instructions, so I don't know what its maximum safe pressure is. However, most pressure cookers seem to go up to about 15 psi. Of course, if you block the safety valve, then it'd go higher, but the safety valve is there to stop the thing from exploding...

This scenario doesn't look good.

A highly flammable gas along with corrosive peroxide heated in a pressure cooker with a disabled safety valve. It's one thing to take your microwave up to 1500 degrees Celsius, but it would seem foolhardy to make what is essentially a bomb.

Professor Cilliers had tried to warn me away from messing with plastic. He told me that he'd spent a lunch discussing how I might be able to make some plastic from oil, with a friend who works in the chemical industry, and they had concluded it was impossible. But it's essential that I make a plastic case for my toaster.

Well, we can blow up that bridge when we come to it. First things first—I need to get hold of some crude oil.

* * *

BP: Hello, BP press office. How can I help you?[†]
 ME: Hi, my name's Thomas Thwaites, I'm a
 student at the Royal College of Art in London.
 I was wondering if I could speak to someone
 about a project I'm doing...
Hold on while I put you through please. [brief
silence] Hello, Robert speaking.
 Hi, Robert, my name's Thomas Thwaites, I'm a
 student at the Royal College of Art in London.
Hello.
 I'm calling because I'm undertaking this
 project and I was hoping BP might be
 interested in getting involved. You see,
 I'm trying to make a toaster.
Err. Right.
 The thing is, I'm making it from scratch.
 That is, starting from raw materials. So
 before Christmas I went to an iron mine, and
 got some iron ore. I smelted it and now I'm
 forming it into the bars of the grill to
 make a toaster.
I see. And where exactly does BP fit into this?
 Well, the casing of a toaster is plastic,
 and so is the moulding of the plug, and the
 insulation of the power cord. And plastic
 comes from oil, right?
Err yes.
 And BP drills for oil, right?
Yes.

[†] It's not polite to record people's phone conversations without telling them (it's
also mildly illegal), so I didn't record this conversation, and so this isn't a direct
transcription, but you get the picture...

So I was wondering if I might be able to come
and hop on one of your helicopters to one of
your oil rigs and pick up maybe a jug of oil?
I see. It's not a trivial thing to take a
helicopter to an oil rig.

I know, I just thought that you must have them
going out there all the time, and so if there
was a spare seat I could just sort of tag
along.
We don't have spare seats in our helicopters.
It's just not something you can do casually.
Everyone who goes out has to do emergency
training. The course takes a couple of days...
[muffled speech in the background] No, I've just
been told it now takes a week.

Right... [I vaguely remember seeing something
like it on *Blue Peter*, a long-running
children's BBC television show. It looked
quite exciting]... I've got a week.
You do know that there was a helicopter crash in
the North Sea last week?

No, sorry, I didn't know that.
There was. They all got out because they'd done
the training course. As I say, it's not a casual
undertaking. The other thing is that crude oil
isn't a benevolent substance. In fact, it's highly
dangerous and we never allow it on helicopters.
Especially not in a jug.

Maybe a jerry can? Maybe it could go by boat?
We're just not set up for the kind of scale you're
working at. If you wanted a tankerful, we could
maybe help, but...

 It would be great PR for BP...

In what way?

 Well, my project has been blogged, a
 journalist from the *New York Times* got in
 touch, *Wired* magazine, there's even an article
 in *Hemispheres*, the in-flight magazine of
 United Airlines.

I don't think BP would fit into this. It sounds
like your story rather than BP's.

 It could be BP's story too... You know,
 "BP a multinational corporation helps person
 make a toaster" sort of thing.

Yeah. Not sure. I can't really think of a way to
do this. Look, let me have a talk with some of my
colleagues and if we can think of an angle we'll
give you a call back.

 Great. Robert, you won't regret it.

 My number is...

 * * *

While I waited for BP to get its act together, I set about making the mould I would need to form the plastic into a casing. The usual moulds for making toaster cases are incredibly expensive engineered pieces of steel, because they have to withstand hot plastic being injected into their cavities at extremely high pressures, and then cool evenly so the plastic doesn't distort as it solidifies. I'm going to make my mould from wood.

Carving requires a hammer, a chisel, a block of wood, and a lot of patience. Across the road in the park some tree surgeons were conveniently chopping down a tree because, coincidentally, it was mouldy. I secured two big lumps from the trunk and set about carving a positive and a negative that, when slotted together, would leave a toaster casing–shaped cavity.

The difficult thing is to make the two parts of the mould match, so that when they're put together the space between them, which will be filled with molten plastic, is even all the way round. Of course, when I slot the two parts together I can't see whether the gap between them is too thick or too thin, so to judge whether one needs to shave a bit more off the side involves a lot of jiggling, rocking, squashing clay, swearing, and so on.

Still, it happened to be nice weather, and carving outside beats sitting in front of a screen, drawing a toaster with 3D-design software. It's a classic case of tools determining outcome. With software it's easy to make things smooth and straight, and a total hassle to make stuff rough and irregular. As I discovered, when you're carving it by hand out of a bit of tree trunk, it's rather easy to make things uneven and rough, but really quite time-consuming to make things smooth. Personally, I'd welcome a bit more random unevenness in products.

Making a mould for the plastic casing

The female part of the mould, or the "mould cavity"

About a week later, and I was still carving my mould. BP still hadn't called back. I was getting concerned.

Days later, and I'd finally finished my mould, and still nothing from BP. I decided to phone them again. Robert put it bluntly—there was "no way" it was going to happen. My conversation with BP took place before the large oil spill from their Deepwater Horizon oil rig. I expect Robert has a lot on his plate now, but perhaps he'd be a bit keener on a jolly man-makes-toaster story to help counteract all that negative coverage. Perhaps not. In any case "British Petroleum PLC" (as it called itself until 1998), plastic derived from fossil fuels, isn't the only game in town . . .

There are plenty of "bioplastics"—plastics derived from plants or bacteria. The first plastics were technically bioplastics. These came even before Bakelite and were developed primarily as a "synthetic ivory"—at the time there was much concern about

The male part of the mould, or the "plug member"

what piano keys and billiard balls would be made from when all the elephants had been used up.

PLA, or polylactic acid, is a bioplastic used to make disposable cups. The lactic acid comes from bacteria-fermenting sugarcane. I remember that lactic acid buildup is what makes our muscles sore when we exercise. I quickly dismiss the idea of vigorous aerobics followed by somehow harvesting the lactic acid from my muscles as just a bit horrible.

It's even possible to make standard polyethylene from sugarcane rather than crude oil. All one need do is ferment the sugar into ethanol, convert it to ethylene, and go from there. Sounds promising. I discover a place called the National Non-Food Crop Centre and seek some advice.

* * *

From: Thomas Thwaites <thomas@thomasthwaites.com>
To: a———@nnfcc.co.uk
Date: 19 March 2009 18:08
Subject: **Toaster Project and Plastics?**

Dear Adrian,

It's Thomas Thwaites here . . . we spoke briefly on the phone
on Wednesday about my "Toaster Project" and the possibilities for
making polypropylene at home. I'm emailing to find out if you'd
had a chance to discuss it with your colleague yet, or had thought
of any other possibilities for making the plastic casing for my
toaster, and the plug and power lead. I have already purchased
a pressure cooker as I imagine it could make a nice high-pressure
reaction vessel!

Look forward to hearing from you,
Thomas

From: Adrian Higson <a———@nnfcc.co.uk>
To: Thomas Thwaites <thomas@thomasthwaites.com>
Date: 20 March 2009 11:21
Subject: **Re: Toaster Project and Plastics?**

Hi Thomas,

I think you need to understand the complexity of plastic production; it is considerably more complex than metal production.

The complexity comes from the level of processing; metals are refined at the physical level through heating and cooling etc., as you know. Plastics, on the other hand, are processed through a combination of physical and molecular transformations (the breaking and reforming of molecular bonds). The chemical transformations require strict control of temperature, pressure, mixtures of chemicals, and the use of catalysts (in themselves difficult to make).

It takes a number of steps required to produce any plastic. Polyethylene, probably one of the simplest polymers, requires several steps to produce and the plastic used for toasters, PBT, requires a minimum of six chemical transformations to produce. I hope this is not too depressing and I'm happy to discuss it further. We had a good discussion in the office trying to think of a solution to the problem and came up with something you could try and make.

Going back to the complexity of the production I would offer the following view: We've been making iron since the Iron age, but we've only been making plastic for ~100 years (most only for 60 years). The time it took us to go from iron to plastic indicates the difference in complexity.

Regards,
Adrian

This is a less than encouraging reply, but still with a glint of hope.

It turns out that what I can try is a starch-based plastic, specifically, potato starch plastic.

I ponder potatoes.

I would, after all, still be digging up my raw materials, but they'd be fresh instead of millions of years old. The starch-based plastic my potatoes would make would be quite different from the polypropylene I was originally going for.

Instructions:

Take some raw potatoes, cut them up. Blend them. Fail spectacularly to separate the liquid from the solid using a cafetière (French press). Clean the potato mess from the walls. Have a bit more success using a sieve. Let the fine particles in the liquid part settle to the bottom of container. Tip off the liquid so you're left with very fine, wet potato "flour." Cook this up in a saucepan with some vinegar and a touch of glycerine and after ten minutes or so it forms a translucent goo (sort of like a pot of snot).

I tip the hot potato plastic into one half of my mould and lift the other half into place, using my weight to press the sections together, which causes the excess potato plastic to ooze out the sides of the mould. I then have to wait for it to set.

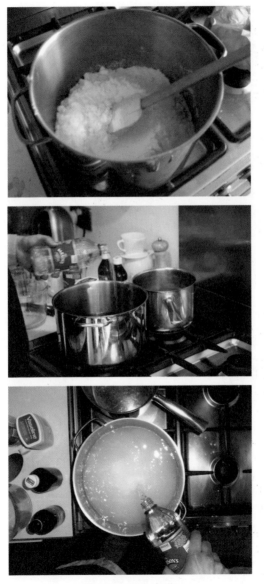

Mixing up potato plastic

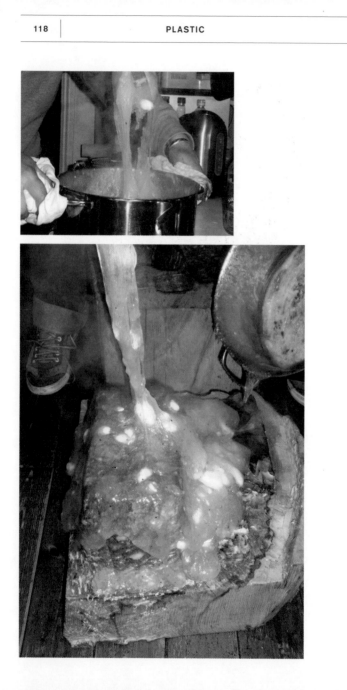

Compressing the mould

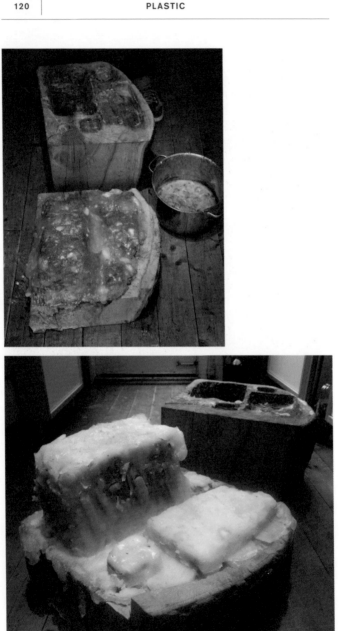

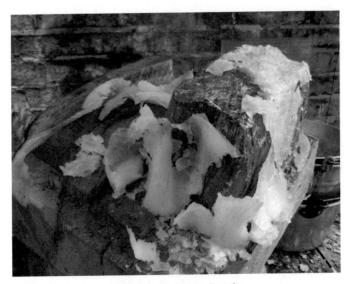

The first plastic attempt—it cracks

A few days later I pry the two halves of the mould apart. I have to use a crowbar because the plastic has stuck them together.

The plastic exposed to the air has set hard, but the stuff in the interior of the mould is the consistency of lard. It's not looking particularly promising. I leave the two halves of the mould apart, hoping it will help my toaster case set evenly.

Over the next couple of days a strong vinegar smell percolates through the house, and I watch with mounting unease as my plastic cracks up as it dries.

Another failure.

* * *

London to Manchester, 173 miles

This situation requires some lateral thinking. In the discipline of geology, a debate is currently raging over whether or not to declare the beginning of a new epoch—the Anthropocene—a geological age of humanity's own making. This would be quite a big deal in geological circles, as epochs don't begin every year—generally more like every few million. The reason a new one is being considered is that geologists in the far future, without any knowledge of our civilisation, would notice sharp changes in the strata of rock that are being laid down today. They would be able to say there had been a mass extinction event (i.e., human society), as fossils of many species would suddenly disappear from the fossil record. A sudden increase in radioactivity would be detected—left over from the two thousand or so nuclear weapons we've exploded since 1945, and "new" molecules would be found in ice cores and rocks, molecules from plastics. Just as rocks have been laid

down during previous epochs, could it not be argued that equivalent rocks are being laid down in the Anthropocene, and that some of these rocks happen to be made of polypropylene, for instance? If I can mine iron ore, can I not "mine" some of this nascent plastic rock at a dump?

I admit that it's a stretch, but they're my rules and I'll break them if I want to.

Axion Recycling is an SME (small-to-medium-sized enterprise) located in Manchester. It takes used plastic and turns it into plastic for brand spanking new things. Its comanaging director is a man named Keith Freegard whom I met at a conference called "Plastics—Greener Than You Might Think." I've come to get some advice from Keith about how I can melt down some plastic that I will "mine" from the dump and turn it into a new toaster.

Meeting with Keith Freegard at Axion Recycling

Keith set up Axion with his business partner because they weren't ready to retire and they'd always wanted to have a factory. Another factor was that when they set it up, something called the WEEE was coming. WEEE stands for Waste Electrical and Electronic Equipment, a directive that the European Parliament signed into law in 2003. I remember roughly following

the passage of this legislation because it promised big changes in how electronic equipment would be designed.

The idea was that manufacturers like Sony, Toshiba, Moulinex, Hitachi, Whirlpool, Bosch, Apple, and whoever else sells electrical products (like toasters) or electronic products (like computers) have to take responsibility for them not only when they're being used, but when they're thrown "away" too.

The thing about recycling is that it's easy to lose quality with each cycle by getting different materials inadvertently mixed together. If you melt down some high-grade aluminium, perhaps parts of an old aeroplane, but some copper wiring gets mixed in too, then the resultant aluminium won't be good enough to be used for aeroplane parts again. So it's used for cans, say, but if these cans are carelessly recycled too, even more impurities are added, and so on for the next cycle, until the metal is so mixed up that no one trusts it enough to use it in their products, so it goes to the dump. This sort of recycling has been called down-cycling— with each cycle the quality of the material goes down, as does the range of things you can use it for, until it's so bad that no one wants it.

This is even more of a problem for plastics. Plastics are difficult to tell apart and so difficult to separate automatically, but they're especially susceptible to contamination: getting a bit of high-density polyethylene mixed in with your batch of polypropylene can ruin it completely. Compounding this is the fact that plastics are relatively cheap, so at the moment it's difficult to make the necessary sorting out pay. In other words, your lovely plastic patio chair made from 100 percent

recycled plastic could just be having a quick stop over at your house while on its way, inevitably, to the dump.

Electrical goods, even the simple cheap ones like toasters, consist of many small parts made of many different types of plastic and metal, all firmly joined together, and electrical waste is the fastest growing type of waste. Those photographs of piles of discarded brick-like honky-looking old mobile phones? Give it a few years and they'll be piles of today's smartphones—which will likely look equally as brick-like and honky-looking to our future selves. The turnover of electrical waste, it seems, is without end.

When originally conceived, the WEEE was going to mean that the manufacturers of these fiddly electrical goods would have to deal with them when you'd finished with them. They'd have to take them back when they'd reached the end of their working life. Therefore, in theory, the manufacturers could save themselves a bit of money in the end if, in the first place, they designed their products so that they could easily dismantle them and sort all the components and materials into nice separate piles that could be reused or recycled. Thus while acting entirely in the interests of saving themselves some money, the invisible hand of the market would guide these companies to make products that were less environmentally harmful.

This led to lots of interesting ideas about how you could design things to be easily and quickly (and therefore cheaply) disassembled. For example, Nokia made a mobile phone that would spring itself apart in the right conditions, and screws were developed that would actually unscrew themselves if heated to the right temperature. Maybe they would start using

standardised components to save themselves more money, making it far easier for parts to be reused rather than melted down and reformed. Even better, as it's expensive to handle toxic materials, the manufacturers would have the incentive to design out those materials right at the start.

The dream was that the WEEE would lead to closed-loop manufacturing. The manufacturers would have a constant incentive to make products that were easier to recycle, because they were the ones that would have to recycle them. This was what was going to happen when the WEEE legislation was first proposed. The problem is, after years of delays in setting up the scheme, Axion Recycling and its competitors aren't dealing with TVs that ping apart into their components at the shake of a stick. They deal with sacks of mixed-up bits of shredded plastics, metals, rubber, glass, or whatever else the electrical goods we throw away happen to be made of. The way the WEEE has been implemented means that Sony (or whoever) just has to purchase a certificate from "equipment recyclers" saying that a certain proportion of electrical goods has been recycled. So if Sony sells a third of all the TVs that year in Europe, it just has to buy certificates to prove it has contributed a third of the money to a recycling scheme for TVs. But Sony doesn't actually have to deal with recycling its own TVs, which means it has no incentive to design them to be easily recycled or reused, it just needs to hand over some cash. This "recycler" (which, according to Keith, quite often could just be a repurposed car-crushing yard) crushes and shreds all the TVs, toasters, microwaves, or whatever, sucks out some of the magnetic metals, sucks out some of the nonmagnetic metals like copper and aluminium,

and then puts what's left in a big bag labelled "plastic." This label is somewhat simplistic, however, because although the bag does contain plastic (of many different types, mixed together) it also contains glass, rubber, and whatever metal was missed earlier. All this is then sent either to the dump, to a company like Axion, or to Axion's competitors; these are the poorest of the poor in the developing world who pick through mixtures of waste, separating out different components and materials. As Keith succinctly puts it: "The legislators ballsed it up."

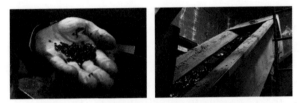
Touring the Axion Recycling factory. Factories are exciting.

On the plus side, as far as my project goes, it turns out that melting a small amount of plastic to remould it is a fairly easy operation. Keith tells me that polypropylene melts at about 160 degrees Celsius, easily obtainable on a normal barbecue.

In the part of his factory where they melt down the old plastic, there's a pervasive smell of, well, melting plastic. A bit like the smell you get when you unwrap a spindle of blank CDs. I ask if these fumes are toxic, but apparently despite the rather acrid tang, as long as the hot plastic doesn't catch fire, it's all fine.

To obtain my plastic feedstock I don't even have to visit a dump. There are often small "mines" of discarded plastic objects on the streets of New Cross in London

where I live. Raiding just one of these piles of illegally dumped rubbish provides me with a cracked yellowy plastic tub and a white plastic baby walker thing. Both are made from polypropylene, which is what I'm after.

My first attempt at melting goes badly. I smash up a bit of the baby walker with a hammer, put it in an old baked bean tin and heat it on a barbecue. The plastic in the tin goes soft, but I'm expecting it to become almost liquid. This is a mistake, because I heat it too much, causing it to ignite and billow out smoke that is without a doubt toxic.

I decide I need a more controlled approach. To melt a bar of chocolate for a cake or something, you can break it into a bowl, and then put the bowl in a saucepan of water and heat that over the stove. Heating the chocolate indirectly spreads the heat around and avoids hot spots, which can burn it. Taking my cue from this culinary technique, I smash up my yellow plastic tub, and put the pieces in a bucket floating in a slightly larger bucket filled in part with cooking oil. I use cooking oil rather than water because I need it hotter than boiling water.

When the yellowy plastic is viscous, I scoop it out of the bucket and dollop it onto my mould. Quickly, before

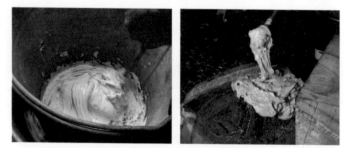

Melting waste plastic to create my toaster case

it cools, I lift the other part of the mould into place, adding my weight to help squish the viscous molten plastic around the edges of my mould cavity. Jimmying the mould apart a couple of minutes later, I'm overjoyed to see the first version of my toaster's case.

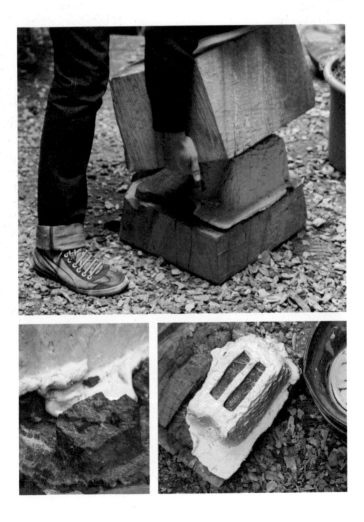

Copper

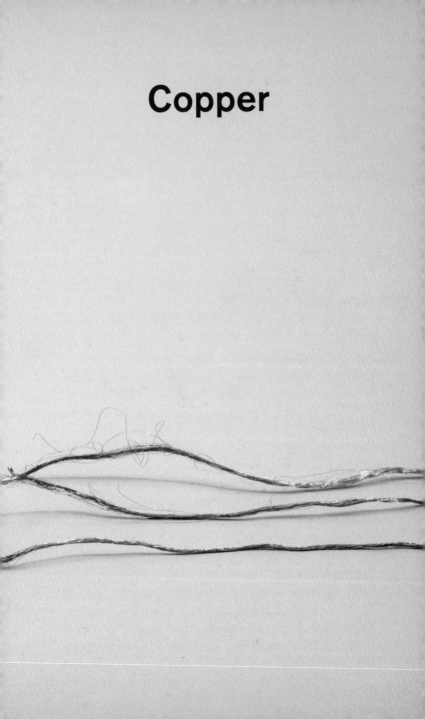

Copper

Professor Cilliers was advising me about extractive metallurgical techniques. His particular specialisation is bubbles. More specifically, bubbles in foam. I am rather astounded to hear that the study of bubbles is a fitting one for the Chair in Mineral Processing at the Royal School of Mines, but this is the world we live in. "Froth flotation" is a process used to separate sand and other bits of rocky stuff from the metal in crushed-up ore. As I understand it, you crush your ore to a powder, add it to a big vat of water with some vegetable oil in it, and mix vigorously. This produces a foam on the top. Most of the tiny bits of metal stick to the bubbles, but the rest of the sand and clay or whatever doesn't. So you get these shiny metallic bubbles that you scoop off and send for smelting. It's probably slightly more complex than that (complex enough for it to become the basis of Professor Cilliers's career anyway), but that's the general idea. On the scale that these plants process ore, if he

can adjust the process so even just a fraction of a percent more copper sticks to the bubbles and is scooped off rather than remaining in the dregs, that fraction of a percent multiplies up to thousands of tonnes of extra copper, and millions of dollars more for whoever is selling it.

I suppose Professor Cilliers not having to spend much time toasting his bread in the morning is one small contributing factor to the reason why he has time to become an expert in bubbles, and in studying bubbles he makes mining copper more efficient, which in turn makes toasters cheaper, which means more people can devote less time to making their toast and more time to other activities, like going to art school and doing ridiculous things like taking nine months to make a single toaster from scratch.

So this is what Adam Smith was going on about in his *Inquiry into the Nature and Causes of the Wealth of Nations* (1776), when he wrote:

> In the first fire-engines, a boy was constantly employed to open and shut alternately the communication between the boiler and the cylinder, according as the piston either ascended or descended. One of those boys, who loved to play with his companions, observed that, by tying a string from the handle of the valve which opened this communication to another part of the machine, the valve would open and shut without his assistance, and leave him at liberty to divert himself with his playfellows. One of the greatest improvements that has been made upon this machine, since it was first invented, was in this manner the discovery of a boy who wanted to save his own labour.

All the improvements in machinery, however,
have by no means been the inventions of those who
had occasion to use the machines. Many improvements
have been made by the ingenuity of the makers of the
machines, when to make them became the business
of a peculiar trade; and some by that of those who are
called philosophers or men of speculation, whose trade
it is not to do anything, but to observe everything; and
who, upon that account, are often capable of combining
together the powers of the most distant and dissimi-
lar objects. In the progress of society, philosophy or
speculation becomes, like every other employment, the
principal or sole trade and occupation of a particular
class of citizens. Like every other employment too, it is
subdivided into a great number of different branches,
each of which affords occupation to a peculiar tribe
or class of philosophers; and this subdivision of employ-
ment in philosophy, as well as in every other business,
improves dexterity, and saves time. Each individual
becomes more expert in his own peculiar branch,
more work is done upon the whole, and the quantity
of science is considerably increased by it.

It is the great multiplication of the productions of
all the different arts, in consequence of the division
of labour, which occasions, in a well-governed society,
that universal opulence which extends itself to the
lowest ranks of the people. Every workman has a great
quantity of his own work to dispose of beyond what
he himself has occasion for; and every other workman
being exactly in the same situation, he is enabled to
exchange a great quantity of his own goods for a great
quantity, or, what comes to the same thing, for the
price of a great quantity of theirs. He supplies them

abundantly with what they have occasion for, and they accommodate him as amply with what he has occasion for, and a general plenty diffuses itself through all the different ranks of the society.

And so the extraction, processing, and forming of materials into useful labour-saving products continues at ever-decreasing costs, which means more people can afford these things, and we all gradually become richer.

There was a famous wager made in 1980 between the environmentalist Paul Ehrlich and his crew, and an economist named Julian Simon. Ehrlich was one of the authors of a best-selling book published in 1968 called *The Population Bomb*. It predicted famines engulfing whole continents in the 1970s, caused by over-population and the exhaustion of natural resources. Simon challenged Ehrlich and friends to put their money where their mouths were, and pick five different natural resources that would be scarcer in ten years' time. This scarcity would be reflected in the price—if the prices of their five materials rose over the ten years, then Simon would pay the difference to Ehrlich and the gang, whereas if the prices fell, Ehrlich would have to pay Simon the difference. Ehrlich and his colleagues chose five metals—chromium, copper, nickel, tin, and tungsten—and the period 1980 to 1990. At the time of the bet they said that they'd "accept Simon's astonishing offer before other greedy people jump in," as the "lure of easy money can be irresistible."

It's 1990. I'd been alive for ten years. *Home Alone* was on at the cinema, Windows 3.0 was out, somewhere in CERN the first "World Wide Web" page was put up, and the real prices of chromium, copper, nickel, tin, and

tungsten have all fallen (the "real price" is the price after general inflation has been taken into account). Ehrlich and the gang are gutted, and amongst a lot of embarrassing efforts to get out of it, hand over a cheque for $578.00, the combined fall in price of all five metals.

* * *

London to the Isle of Anglesey, 288 miles

On a sunny day in April my girlfriend and I (Simon couldn't get time off work), set out in a car with three empty twenty-litre watercooler bottles (which I'd found in one of the handy New Cross street dumps). We're heading 288 miles to the Isle of Anglesey in the far north of Wales to meet a retired geology professor, David Jenkins. The drive up takes slightly longer than expected because somehow we cross the border into Wales twice, but eventually we meet David and head over to Parys Mountain.

I've been put in touch with David by a chap at Anglesey Mining PLC, a firm that's trying to raise money to reopen mining on Anglesey.

Anglesey Mining PLC has spent close to £100,000 drilling bore holes to try and discover what's underground. They've even dug a "test shaft," with a classic-looking mining lift at the top of it. This lift "fell off the back of a lorry," according to David, though as it looks like rather a big thing to steal, maybe he means it did actually fall off the lorry when they were trying to put it up. Nearby to the test shaft is our destination, Parys Mountain.

David is quite a calm person; I can imagine him giving geology lectures at Cardiff University where he was a lecturer. He is also a founding member of Parys Underground Group, a club dedicated to exploring and preserving the old copper mine at Parys Mountain. Along with Alan Kelly, also a member of Parys Underground (as well as being the local mountain rescue volunteer), he's offered to take us into the old copper mine, to fill up the mineral water bottles with highly acidic water that contains dissolved traces of arsenic, iron, aluminium, and, most important, copper.

The reason I'm getting water instead of rock is that I plan to extract the copper using electrolysis. Professor Cilliers suggested that this hydrometallurgic process would be the easiest way to go, and after my attempts at extracting iron by melting the ore I'm inclined to agree.

Besides, the mine is a historical site, and it's considered vandalism to hack off rocks (even if it wouldn't seem to make much difference to the look of the place), as well as the fact that to remove them I would need permission from the holder of the mineral rights. This is the Marquis of Anglesey, who is descended from the first Marquis of Anglesey, who was made Marquis as a reward for his bravery in leading a cavalry charge against the French at the battle of Waterloo, and to make up for having his leg blown off by a cannon. In fact, strictly speaking, I shouldn't be removing anything from the mine at all. I'll be stealing my water from the Marquis of Anglesey.

We descend into the mine wearing boiler suits and hard hats with headlamps. It feels actually quite treacherous, with flooded shafts dropping away on either side of the tunnels we walk through.

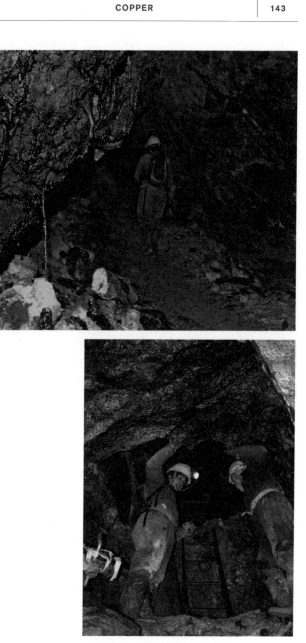

Alan points out a footprint in the mud that he claims is from the clog of a miner, left one hundred years ago. Mining at Parys has been going on since the Bronze Age. They know this because they found a shaft sunk from the surface with charred bits of wood at the bottom that they had carbon-dated to 4000 BP (before present), the Bronze Age in Britain. Back then people didn't have pickaxes or explosives, so they dug these shafts and lit hot fires at the bottom, and poured over water to crack the rock. Then they had to smash it up further with stone boulders to break up the bits containing copper. Sounds like hard work.

After about fifteen minutes of walking (mostly at a crouch), we reach the descriptively named "brown pool." This is a domed chamber, about ten metres across, that's home to the aforementioned pool of water. Its colour suggests it is highly contaminated, so David suggests filling the mineral water containers here. Each one has "Only to be used for mineral water" stamped into the plastic on the neck. "Well, technically," I think to myself, "I *am* filling them with mineral water, only these minerals are toxic and/or present in rather higher concentrations than your average bottle of Evian."

The water is reddy brown and has a pH of about 2; this is the strongest acidity that's found naturally. The chemistry is "complex," as David says, but the reason the water is so acidic is that it has reacted with the rock exposed by the mining. This acidification occurs wherever water and air come into contact with the type of rock that can contain metals—so not only in the mine itself, but also on the surface in pools between the tailings dumps, the vast heaps of crushed up waste rock. I ask if the acid would strip me to the bone if

I fall in—no, but it would sting a lot if it got into my eyes. Nothing can survive in it, except a type of organism so bizarre that no one even thought it existed until they discovered some happily living in the geothermal vents at Yellowstone Park in the 1970s. These microbes, called "extremophiles," not only survive in extreme conditions like acidic water or hot tar, they thrive in them. In fact, the extremophile microbes living in mines contribute massively to the acidification of the water by slowly "eating" the rock and excreting acid. They are studied by astrobiologists, because it's imagined the extreme conditions they live in may be similar to environments found on other planets.

Underground with David Jenkins

Metal dissolves in acid, which is why the water I'm collecting has metal dissolved in it. David tells me that copper is present in a concentration of "two hundred parts per million by volume." This means that for every million teaspoonfuls of water, I would get just two hundred teaspoonfuls of copper. I reckon I need around one hundred grammes of copper to make the pins of the plug and the electrical wiring. A teaspoonful of copper would weigh 44.6 grammes (in the United Kingdom at least—in the United States it would weigh less because spoons there are slightly smaller). This means 11,210 teaspoons of mine water should contain the one hundred grammes of copper I need for my toaster, or using more standard units, about fifty-six litres. Which is why I've come to the mine with the biggest water bottles I could find, twenty litres each. Each filled bottle weighs about twenty kilogrammes, which is very heavy to hold in one hand while having to use the other to climb up slippery 150-year-old ladders. David, who isn't quite as reckless as me, decides it would be foolhardy to attempt.

There is a backup plan, however.

There are pools on the surface amongst the tailings dumps that also have copper dissolved in them, but at slightly lower concentrations, meaning less copper for my toaster. Still, it seems it really is our only choice. We fill up two smaller containers with the good stuff from the brown pool and return to the strange but quite beautiful surface landscape of Parys Mountain.

* * *

Plan B, filling containers from pools amongst the surface tailings dumps

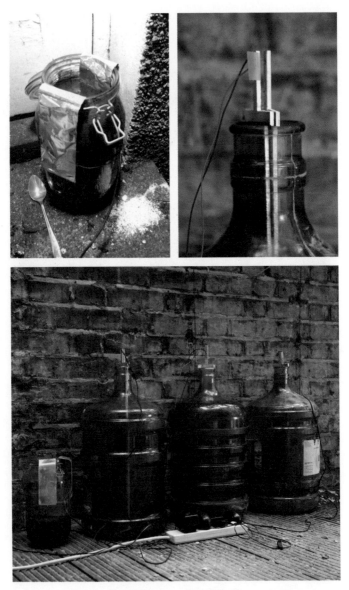

Extracting copper electrolytically

Casting the three copper pins in cuttlefish shell moulds

The finished pins for the electric plug

Rio Tinto is a descriptive name for a river in Spain. Its waters are red and highly acidic for exactly the same reason as those at Parys Mountain, acidification caused by disturbed rock and bacteria, and except for those acid-loving bacteria, it's lifeless. The Rio Tinto gave its name to Rio Tinto PLC, "one of the world's leading mining and exploration companies," which was started there in 1873. Around the world, acidification of water from mine workings is a major environmental problem, or in some places could soon become one.

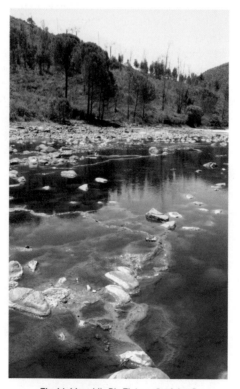

The highly acidic Rio Tinto, or "red river"

From: Matt Davidson <b————@gmail.com>
To: Thomas Thwaites <thomas@thomasthwaites.com>
Date: Friday 13 February 13:37:56 2009
Subject: **greetings from Alaska...**

Thomas,

Greetings from Alaska, USA. Quite an interesting project—I wish you good luck. I found your "Toaster Project" site from a link on the Pebble Limited Partnership website (www.pebblepartnership .com). The proposed Pebble project is a massive open pit gold and copper mine located in the most wild Sockeye salmon fishery in the world. I work with a coalition of commercial and sport fishermen, Alaska indigenous peoples and other locals opposed to the proposal. Given your interest in avoiding becoming a "how it is made" industry promotional project, I thought you'd be interested in Pebble's (UK's Anglo America) promotion of your website. You might consider how this might impact your project. As an aside . . . I'd gladly give up toast if it would help safeguard this wonderful place.

Matt

From: Thomas Thwaites <thomas@thomasthwaites.com>
To: Matt Davidson <b————@gmail.com>
Date: Monday, February 23, 2009 9:22 AM
Subject: **Re: greetings from Alaska...**

Thanks for the heads up Matt,

It's slightly bizarre to be put on their website . . . which is quite gross... especially all the holding hands mosaic whales etc. (the designer should be seriously ashamed). I've saved a copy of the website for possible use later...

"The Toaster Project" is really a work in progress which got blogged prematurely. Some people (like Pebble) have missed the critical angle... the ridiculousness of churning out thousands (millions?) of toasters and other products at the expense of the environment and human sanity (the cheap toasters I've taken apart have been hand soldered). However, there is also clearly a ridiculousness in undertaking to make a toaster myself, an activity that will produce a single toaster with a far larger carbon footprint than any toaster bought from the shops. It's kind of disturbing to be faced with the reality of the ambiguous "position" of the project though...

I guess I want to argue against both positions stemming exclusively from the demand side (consumers demand toasters therefore copper therefore open cast mines in remote wilderness), and the supply side (e.g. to argue that mineral extraction is wrong... then to go and make some toast).

As you say, you would give up toast to protect Bristol Bay... if only it were that simple. With your permission could I publish this correspondence (if I do, I'll happily include the link to your campaign).

All the best,
Thomas

Pondering this later I come to the conclusion that you've got to stop somewhere. The thing about mining is that you're digging big holes in the ground. Big holes in the ground have a tendency to fill up with water—particularly in wet places such as near to the headwaters of Alaskan rivers. The water in these holes will become acidic—particularly so due to the high sulphur content of the Pebble prospect ore. In fact, if the mine were to be named for what it primarily would be excavating, it'd be called a sulphur mine (with a little copper mixed in). Sulphuric acid and Alaskan wilderness do not mix well, and the problem of how to stop them from mixing would remain for centuries after the mine is exhausted.

Metals will be valuable for the foreseeable future, and presumably extraction techniques will continue to improve, meaning more and more ore deposits of lower and lower grades will become economical to mine, meaning the "market" will demand to mine them. The pressure to open up more sites to exploitation is therefore not going to diminish. But unless you apply the brakes at some point, we could end up living in one big mine, so to speak. Also, unless we apply the brakes there won't be much incentive to come up with less environmentally damaging ways of doing things. The Pebble Project would seem to me to be a good place to stop.

www.savebristolbay.org

Nickel

Nickel

I have a problem.

Nickel is essential to make the toaster element, but I can find only one site where nickel has been mined in the United Kingdom, and this mine has a big metal grate covering the entrance. There is scant information about it. My confidence hasn't been buoyed by the responses I've been getting from people I've spoken to along the way when I ask them about finding some nickel ore within a sane distance of my house.

There is a large nickel mine in Siberia, in a place called Norilsk. This is Siberia's northernmost city, sited on top of one of the largest nickel ore deposits in the world. For a city to exist in such a harsh climate (the *average* temperature is minus ten degrees Centigrade, with blizzards for 110 days a year) it needs a pretty good reason. The exploitation of the nickel deposit has provided one since the 1930s, though much of the exploitation until 1953 (perhaps even as late as the 1970s)

was done by the forced labour of political prisoners, sentenced (either with or without a trial) to mine nickel in incredibly dire and often fatal conditions. Nowadays, Norilsk has the slightly less (or more?) dubious honour of being one of the ten most polluted places in the world (as listed by the New York environmental NGO, the Blacksmith Institute). The smelting of the nickel ore is done on-site, and because of the plumes of sulphur dioxide released in the process, allegedly not a single tree grows for fifty kilometres around the smelting complex, and the topsoil itself has become so contaminated with heavy metals that it would now be economical to mine as well. Sounds rather bleak.

It is a rather difficult place to go without a very good reason, and not just because it's in Siberia. According to the internet, the Russian government has decreed Norilsk a "closed city" to foreigners.

My blog exposure has led to an interesting nickel contact however—someone with connections to the Talvivaara Mining Company, which is just starting to mine a large deposit of nickel ore in the far north of Finland. However (according to the Talvivaara PLC website), the extraction of nickel from the ore won't happen in the usual way—that is, smelting it in a furnace and emitting plumes of acid-rain-causing sulphur dioxide—but in a more environmentally benign way, using a process called "bio-heap leaching." This involves heaping the crushed ore in a big pile and then using a variety of the same extremophile microbes that cause the water pollution problems at mines like Parys Mountain or Rio Tinto to actually extract the metal. A mixture of acid and extremophile, acid-loving bacteria, is sprayed onto the heaps and trickles through,

the bacteria digesting the ore into more acid, sulphates, and nickel. The acid leaches out further nickel, and the whole nickel-rich liquid is collected in channels running under the heaps. One then has only to precipitate out the metal dissolved in the acid solution and voilà—all without so much unpleasant burning of fossilised trees and production of noxious gasses. Excellent, I think, bio-heap leaching is the kind of clever win-win solution us modern humans come up with these days: we get nickel for our toasters, and our bacterial partners and co-inhabitants of Spaceship Earth get a good square meal. Except, as it turns out, it's not that simple. The metal products produced at Talvivaara still need to be smelted in the end. The reason bio-heap leaching had to be employed is because the ore mined at Talvivaara is of such a low grade—the concentration of metal is so low—that it wouldn't have been economical to smelt, unless a cheap way was found to concentrate it first. This nascent technology of bio-heap leaching has found its first application in making un-exploitable ore worth exploiting.

Talvivaara has signed a ten-year contract to sell its nickel product (that is, concentrated nickel liquid) to none other than Norilsk Nickel. However, it's not shipped all the way to the end of the world at Norilsk in Siberia. MMC Norilsk Nickel Group also own a nickel smelting plant at Harjavalta, in southern Finland. Unlike Norilsk, Harjavalta is not one of the ten most pol- luted places in the world. In fact, the smelting plant at Harjavalta has been studied as an example of an "indus- trial ecosystem." Just as in natural ecosystems, where the waste products from one organism are the food source of another, the idea at Harjavalta is that

the waste products of one industrial process form the raw material inputs for another. The idea of an industrial ecosystem is relatively new, and is an ecosystem by analogy only, but it certainly seems like a move in the right direction. It's interesting that although both are owned by the same company, Norilsk Nickel's two smelting plants are polar opposites in terms of their environmental impact. Russia and Finland are also polar opposites in terms of their regulatory environments—one being one of the most corrupt countries in the world, the other one of the least.

Google says it would take me just thirty-six hours of continuous driving to get to Talvivaara from London. It's also a good time of year to see the northern lights. But, I have two weeks before I need to toast at my degree show. I'm also at the very bottom of my overdraft. I consider my options:

A. Break into the alleged English nickel mine. However, as I'm carefully documenting the whole toaster-making process, this presents somewhat of a catch-22. If I break into the mine, which someone has taken such care to seal off, then I might find some nickel ore, or die. Either way I wouldn't be able to tell anyone about it, because in the former case I would likely get done for criminal damage, and in the latter, well, it's obvious.

B. Abandon my degree and travel to Siberia to get some nickel ore from Norilsk. (And possibly face arrest by a Russian policeman—what an exquisite irony however, if I was sentenced to hard labour in the nickel mines! Ha ha ha.) I also don't have any money left to get there.

C. Hire a van and drive to the far north of Finland. Possibly see the northern lights, but possibly miss my degree show. Again, there is that problem of not having any money.

To be honest, none of the three options are particularly attractive/possible. In the interests of my future self I look around for other sources of nickel. I soon discover that the Canadian mint issued a special twenty-five-cent coin each month in the run-up to the year 2000. The twelve commemorative coins were made of 99.9 percent pure nickel.

Tempting. Especially when there's a set of eleven being sold on eBay for only CAN $9.50.

Unfortunately, I may not avoid jail this way either, because, as the Royal Canadian Mint is at pains to reiterate, Section 11-1 of the Canadian Currency Act states:

No person shall, except in accordance with a licence granted by the Minister [of Finance], melt down, break up or use otherwise than as currency any coin that is current and legal tender in Canada.

The offence is not dependent on fraudulent intent. Oh well, what the heck. Unless I go to Canada, the mounties can't touch me.

The eleven Canadian twenty-five-cent coins I won on eBay

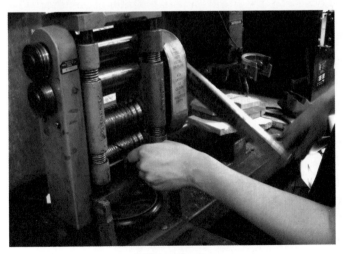

Rolling out the wire

A melted Canadian nickel quarter ready for
rolling into wire for the element

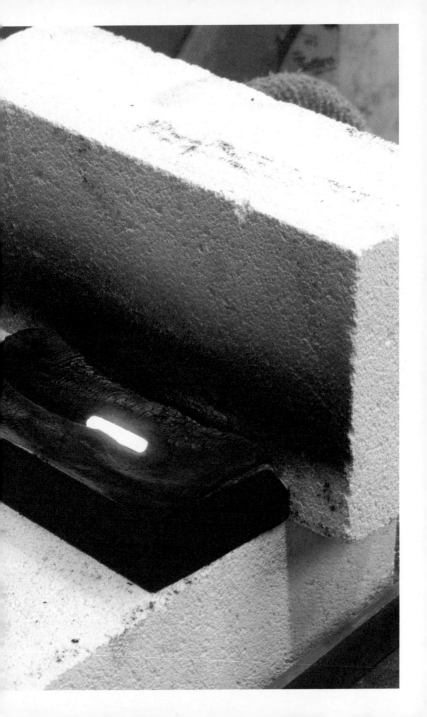

Construction

Construction

Listening back to the recording of my first interview with Professor Cilliers, I'm slightly embarrassed at my naive optimism. "Yes, I'm going to make a steel spring to pop the toast up," and "Yep, I'm going to make all the electronics from scratch too… refining crude oil to make plastic? No problem, I'll just use a cooking pot." I can hear that while he didn't want to pour cold water on my ambition, he knew that the technical and scientific expertise assembled by countless people over centuries could not be replicated by me in the nine months that I had available.

That time is now up, and so I must take stock of the components that I've actually been able to make:

3 bits of iron internal toaster structure
4 iron grill bars
1 iron toast-raising lever
3 sheets of mica

1 top part of the plastic case
1 bottom part of the plastic case
1 top part of the plastic plug
1 bottom part of the plastic plug
1 short length of nickel-copper wire
3 copper pins for the electrical plug
3 copper wires for the electrical cord

Twenty-two parts. My toaster doesn't have a spring to pop up the toast when it's done, or an adjustable timer mechanism, or a cancel button. And it's questionable whether it's actually capable of toasting bread. At the time of writing, I've not plugged it into an electrical outlet, out of respect for the health and safety officer at the Royal College of Art and, if I'm honest, because I'm mildly scared of electrocuting myself or, worse, someone else.

I have plugged it into two twelve-volt batteries wired in series to make twenty-four volts, and the element does get hot. Too hot to touch, in fact (I have a burn on my finger to prove it). But my element doesn't glow red—possibly because the batteries provide ten times less power than the United Kingdom mains electrical supply. This means that, to a pedant, what I've made could at the moment be classified as a bread warmer rather than a bread toaster. I'm still hopeful that I'll see some toast when I up the voltage, or use white bread instead of the whole wheat I've tried so far.

Toast. Has that really been my goal for the last nine months? In one way, yes. But in another more accurate way, no.

I wanted to get under the skin of the slick-looking objects that surround us, but don't really come from

anywhere (unless you work in supply chain management). To the average consumer (like me) a toaster begins its life on display in a shop, waiting for you or someone to buy it. To pay £3.94 for a toaster that's "from a shop" seems vaguely reasonable, but £3.94 for a toaster that is entirely made from stuff that a few months ago was rocks and sludge distributed in giant holes all over the world, then brought together in an elaborate series of processes and exchanges, gradually assembled by many people, wrapped, and boxed and then somehow shipped to that shop, which is heated and lit and has people being paid to assist you in your purchase: Somehow £3.94 for all of this doesn't seem to quite add up.

My attempt at making a toaster myself, from scratch, has been wildly, absurdly, outrageously "inefficient." My toaster cost 250 times more than the one from Argos, and that's just the money I spent on it directly (mostly travelling to mines). If I'd included all the food I ate, and the shoes I wore out, and so on, then its final price would be more. Much more. And its carbon footprint must be huge, at least a size 14 (European size 48).

And thus the miracle of modern capitalism is brought starkly into focus. As Jonathan Ive, senior vice president of industrial design at Apple Inc., said to me (well, me and the rest of the audience), "A complex product being made is like one of those films of a glass smashing that they play backwards—all the bits come together in the right place at exactly the right time to be assembled into this thing—it's amazing." I agree with Mr. Ive; it is amazing. I even have one of his iPhones, which at the moment I quite like (though

strangely it does make me feel like a bit of an idiot when everyone else in the room has one too—like going to a party and everyone's wearing the same "fashionable" top—but that's the point of fashion right?).

However, before we get too chummy with Adam Smith and his invisible hand, it seems that the need to buy more stuff to stimulate our economy, and the need to consume less to save our environment, are on a collision course. So while the £1187.54 price of my toaster doesn't really include all that it cost to make it, £3.94 isn't really what the Argos Value version cost either.

The real "cost" of products is hidden. We don't see (or smell) the pollution emitted when iron is smelted or plastics are made. You wouldn't want it happening in your back garden (though my neighbours have been quite nice about it). Equally we don't have to live with all the stuff we throw "away" (my neighbours I feel sure would complain about a personal garden rubbish dump, especially come the summer). But pollution and rubbish don't just disappear, they end up somewhere, and if not dealt with properly, are costing someone something (their health perhaps). At the moment there's lots of stuff not included in the price of the Value toaster—"externalities" that aren't included in the money economy.

For example, say the copper in the Value toaster was open-cast mined by copper miners in Chile. As we know, large holes in the ground tend to fill with water, which leaches out minerals from the exposed rocks, as happened at Rio Tinto and Parys Mountain. This water, acidified and contaminated with a whole load of heavy metals, such as arsenic, usually finds its way into the nearest river.

At the moment, no one "owns" the river, so the copper miners don't have to pay for stinking it up, and we all get cheap copper for our toasters. Except, of course, someone's paying a cost—like the people living along the river, or relying on it for water. We get the benefit of cheaper copper, but don't have to pay the costs—the costs are external (to us, anyway). However, if *I* owned that river, you can be damn sure that I'd demand a hefty sum from anyone who wanted to turn it into a blood-red home exclusively for acid-loving bacteria. Perhaps it would be so hefty that it wouldn't even be worth mining near my river. Or perhaps the copper miners could haggle me down by agreeing to certain conditions (like being extra careful to not stink up the river). They could then pass this slightly less hefty sum onto the wire manufacturers, who'd pass it onto the toaster manufacturers, who'd then undoubtedly pass it onto me and you—and, to be quite honest, fair enough.

But now imagine the river as the atmosphere, and the whole world's industry as the copper miners. I can imagine myself hypothetically owning a river, but even at my most delusional I can't see myself owning the entire atmosphere of planet Earth. So no one (not even hypothetically) owns the atmosphere, and industry, ourselves, cows, squirrels, etc., are all free to use the atmosphere as they wish, to add a bit of carbon dioxide, methane, sulphur dioxide, and so forth. If no one has to pay anyone to use the atmosphere, then there's no cost associated with polluting it. Environmental regulations are an attempt to impose a cost, but groups with different interests argue for different costs. The Emissions Trading System implemented by the

European Union is an attempt to let the free market in part determine the costs of polluting, but it has run into huge difficulties. In any case, it only applies in Europe.

If all the costs associated with their production were captured, well, toasters would cost a bit more, and perhaps we wouldn't buy and discard them so often, and of course not so many people would be able to afford them…

Here I am, yapping away about how things should be more expensive (well, technically that things *would* be more expensive if we were paying the right price for them). It seems a bit pious to be claiming that I want to pay more for stuff. Well, worse actually, it's hypocritical. Like lots of people, I generally buy the best stuff (that interests me) and that I can afford and probably go on just about as many holidays as I can afford, too (usually on the cheapest flights I can find).

I'm a willing beneficiary of the cheapness of things. When I go to buy my next computer (I'm interested in computers), I'll certainly be looking at the prices of all the different choices very carefully and will buy the fastest, newest one I can get at the best price I can find. I can say this with some certainty, because that's what I did the last time I bought a computer, and the time before that. My present computer is supposedly much better than my first computer, for all sorts of reasons, but the thing is, I don't feel *that* much better off—many of my friends *still* have better computers than me.

We compare what we have with what other people have. Poverty, then, is relative—that's not to say it isn't a very bad/uncomfortable/life-shortening/fatal position to be in, just that it's not an absolute. What it means to

be "poor" changes through time and across the world—as does what it means to be "rich," "well off," or merely "comfortable" (though what it means to be "starving" is flatly invariable). In terms of toasters, if everyone else has a toaster and I don't, well, I'll feel a bit deprived, and I'll go and buy a toaster if I can afford it. The fact that wealth is relative is, I think, one thing that drives the economy. It's not that people have "infinite wants" (as economists traditionally claim), just that no one wants to be at the poor end of the scale.

So, to expect people to stop wanting things when other people have more than them (and sometimes a lot more), because of costs that are difficult to even conceptualise, is I think a bit unrealistic. It's not that people are selfish and nasty—just that we're all constrained by lots of things, especially by what the people we're in contact with are doing, or have. It's a lot easier to give up smoking if the people you tend to smoke with are giving it up too (so far, so good anyway). People's attitudes to modern life won't *suddenly* change because of the (generally) slow and undramatic progression of climate change and environmental degradation—especially if the perspective they see "modern life" from is that of someone who's not currently living it. Developing countries are developing; what happens when every household in China can enjoy a toaster bought for only a few yuan? As a Chinese fashion designer told me while we were in wealthy and minimalist Stockholm, "Here, less is more. In China, more is more."

The collision of the economy with the environment is happening now… if it were a film of a car crash in slow motion, then I guess the front bumpers would be crumpling and bits of glass would be flying up as the

headlights smash. So how can we make the collision more of a glancing blow as opposed to a chaotic and bloody head-on pileup?

There's a whole battery of ways to make this come about—economic means like landfill taxes, giving pollutants the monetary cost they deserve, more and better consumer information. The answers, I think, already exist (lots of people, many of them more clever than I, have given it much thought), they just need to be implemented. Of course the implementation is the tricky part, especially if legislation is required, and legislation is where the big changes can be made. Differing legislative environments are why the same company can operate both the world's dirtiest nickel smelter in Siberia and one of the cleanest in Finland. We're just in need of politicians with the gumption to act.

Recently I heard this quote from the American environmentalist David Brower: "Politicians are like weather vanes. Our job is to make the wind blow." I'm not sure whose job he means specifically, but I think the analogy of culture as wind is a good one. And the direction the cultural wind blows is shaped by economics, fashion, science, literature, beliefs, technology, stories, news, events… all mixed up together. Right. So does that make it pretty much everyone's job to help keep the cultural winds blowing in the right direction? But many of us already have jobs, and don't want a second one if we can help it. Maybe more of a pastime then?

My attempt to make a toaster has shown me just how reliant we all are on everyone else in the world. Though there's romance in that idea of self-sufficiency and living off the land, there's also absurdity. There is no turning

back the clock to simpler times—not without mass starvation anyway. Besides, the majority of the world is still trying to turn the clock forward.

It also has brought into sharp focus the amount of history, struggle, thought, energy, and material that go into even something as mundane as an electric toaster. Even if we still don't have to directly pay what it costs, we can at least value it for what it's worth. Looking beyond just toasters, this means making sure the stuff we need to buy lasts longer, and investing as much ingenuity and money taking things apart as we do putting them together. My trip to Axion's polymer recycling factory was informative on this score. Perhaps there should be two instruction books with every product: one detailing how to set the product up and use it, and another detailing how to take the thing apart and separate it into the different components or materials from which it's made, ready to be fed back into other products without degrading the quality of the material. Is it unrealistic to imagine "the consumer" taking apart and sorting everything that they throw away? At the moment it seems completely so—who would spend an evening dismantling their old toaster or television? The health and safety issues would also be difficult. ("Step 1: Unplug your appliance. Dismantling your toaster while it's still connected to the power supply could be hazardous!")

But there's not much point in imagining futures that are the same as the present. For one, it's not very interesting, but it's also not very useful, and can be dangerous. For example, lots of banks made lots of loans because they assumed the future was going to be basically the same as the present, and look where it

got them (and us). The extent of the kind of change needed to avoid a nasty maiming collision can be summarised by many different statistics, one of which is that 60 percent or more of ecosystem "services" are being degraded or used unsustainably (ecosystem "services" are those important things we get from the environment—like fresh water, clean air, soil in which to grow things, and so on). Other statistics are available. The point is, big changes are needed, and big changes happen. Whether we end up dismantling our old TVs, or paying someone else whatever makes it worth their while to do it for us, doesn't really matter—what matters is that getting rid of stuff you no longer want has to become worth doing properly.

I've had rather a nice time visiting places as well as making my toaster. It's certainly something that I'll never throw away, because (to put it cornily) it embodies so many memories: walking the highlands of Scotland, clambering through the shafts of Parys Mountain in Wales, the Santa's grotto at Clearwell Caves. Companies spend a lot of money trying to invest their brands with emotion and meaning. For me, the stuff that really has emotion and meaning attached to it is stuff with a bit of history. The provenance of things is important. Maybe when we're in school each of us should assemble our own toaster, our own kettle, our own little microwave or something, then perhaps we'd be more likely to keep these things for longer, and repair and look after them. This would mean these products would be more than things that just come "from the shops."

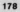

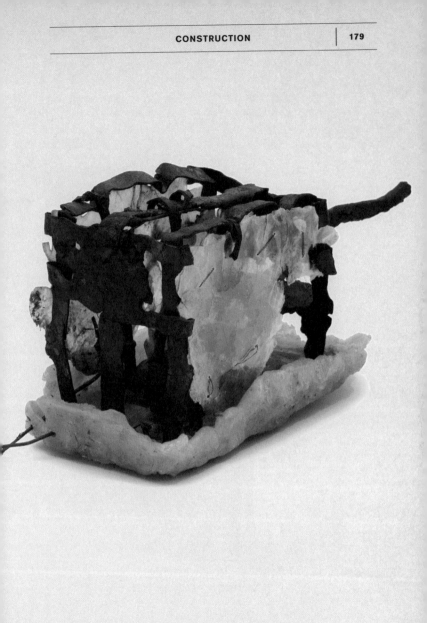

The toaster without its casing

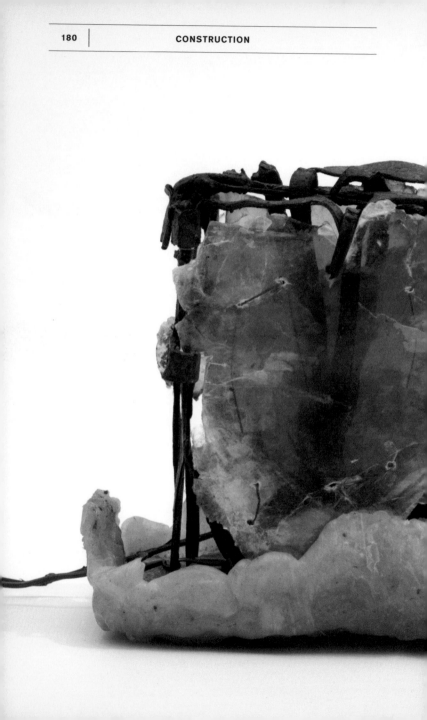

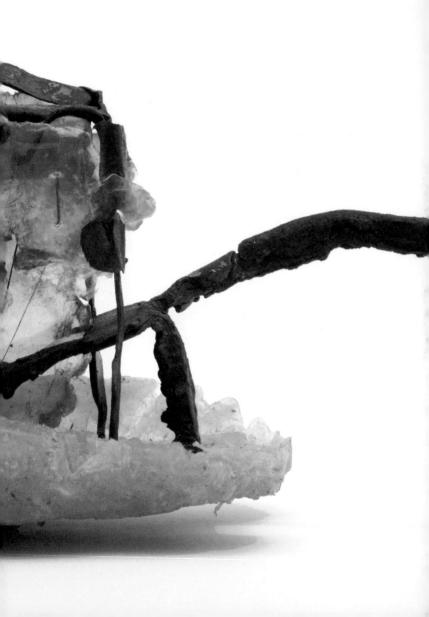

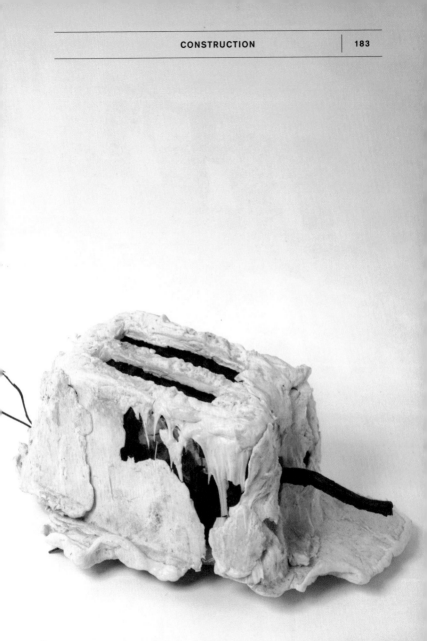

My toaster

£24.95

Theoline TTP102
2 slice toaster
£1187.54
- No heat facility, insures bread settling
- 2 level facility

Kenwood TTP10
2 slice toaster
£16.45
- No heat facility, insures bread settling
- 2 level facility

Bosch TAT610GB
2 slice toaster
£24.45
- Extra-wide adjust in shallow or thicken
- Variable browning
- Warm setting, frozen bread setting
- Manually lift setting
- Defrosting control
- Automatic 2 year

Kenwood TTP103
4 slice toaster
£22.95
- No heat facility, frozen bread setting
- 2 level facility

KENWOOD

Let us lighten
your load

Please ask for details

I know it is but a modest volume, so pages of thank-yous may seem a bit overblown. But I'm writing them anyway because, firstly, it's pretty exciting to have a book actually published (it may be my first and last, after all), which means it'll be in the British Library, Library of Congress, and other important libraries (please drop me an e-mail if you're reading this in one of them, it'll make me feel distinguished). Secondly, and much more importantly, my toaster project and the publication of this book couldn't have happened without lots of people helping me somehow, most of whom (I hope) are thanked below.

This book had a first incarnation—as documentation of a project I did for my MA at the Royal College of Art in London. The first incarnation was designed by the excellent graphic designer A Young Kim, who put up with a lot of faffing from me, and being given gigabytes of unorganised photos and half-finished text documents, which she amazingly turned into a really great-looking (very) limited-edition book.

Since the first incarnation, the content hasn't changed all that much, but perhaps my thinking has. If you would like to discuss any of the issues raised, please feel free to get in touch. And, thank you for bearing with me, dear reader!

My thanks and gratitude to: Jan Cilliers at Imperial College of Science and Technology, for his continuing encouragement, advice, enthusiasm, and lunch(es). Simon Gretton, for being dragged around Britain on what could fairly be described as a harebrained scheme, for his sage advice, and for putting up with a lot from me (though to be fair, vice versa on that, Si).

Daniel Alexander, truly excellent photographer, who spent many of his evenings taking photos of toasters. John Tardrew, unofficial scientific advisor. Clare Ryan, for her help with editing the text and publicising the results. Nelly Ben Hayoun, for being anonymous while being dragged around (and under) Wales. Noam Toran and Nina Pope, tutors at the RCA, for their sharp kicks of encouragement. Anthony Dunne and Fiona Raby for making the Design Interactions MA a place where toasters can be made from scratch, and saving me from a life as a bad web designer. Tim Olden, RCA Design Interactions technician par excellence, who likes to say yes. Andy Law, mentor. Michael Bierut, for showing the previous incarnation of this book to Kevin Lippert, publisher of Princeton Architectural Press, and to Kevin and the press for publishing it, especially Sara Bader, editor, and Paul Wagner, designer.

Thanks to the Thwaites and Percy families (Marty, Kitty, Adam, Rosie, Mark I, Mark II, Virginia, and Juemin), and especially my mother, Lyndsay Thwaites, and my father, Philip Thwaites, for, in summary, being the most generous and forbearing parents that I know of.

Steel… Ray and Jonathan Wright at Clearwell Caves and Ancient Iron Mine, for giving me some of the ore from their display. Irene Gunston at the Royal College of Art Foundry, for being so generous with her time and expertise and her assurance that "no," I wasn't pestering her. Steve Brennan, RCA Sculpture Technician, for the loan of his anvil.

Mica… James Westland of Mull Geology, for telling me roughly where to find the Knoydart mica mine.

Tommy McMammon for being interviewed while
a bit drunk. Sam Firth in Knoydart for being jolly nice
and putting me in touch with her sister.

Plastic... Keith Freegard of Axion Recycling, for the
tour of his factory and discussing the WEEE with me.
Adrian Higson, at the National Non-Food Crops Centre,
for potato advice. The neighbour up the road who fixed
the car the night before. The neighbour across the road
who helped me saw through my wooden mould.

Copper... David Jenkins of the Parys Underground
Group, for soup and taking us down Parys Mine. Alan
Kelly of the Parys Underground Group, for bread and
taking us down Parys mine.

My apologies to: Sam Firth's sister for losing touch.
Many of the people above for not sending them a copy of
this book sooner, or thanking them enough for their time
and help. The people I've forgotten to thank above but
really, really should've.

E & OE!

If *The Toaster Project* has been an intellectual journey, all I've been doing is looking out the window as my train rushes through the intellectual landscape. Occasionally I've gotten off at a station to snack on an intellectual ham and cheese croissant, but mostly I've only stopped to change trains.

I claimed earlier that lots of people more clever than I had given the questions re-raised by *The Toaster Project* lots of thought, and that diplomatic solutions to the growing conflict of environment and economy are out there. Well, I wasn't lying, and here are a few books written by people who've been doing a lot more than intellectual snacking and have influenced me and the writing of this book.

Adams, Douglas. *Mostly Harmless*. London: Pan Books, 1993.

Gardner, Gerald T., and Paul C. Stern. *Environmental Problems and Human Behavior*. 2nd. ed. Boston: Pearson Education, 2003.

Grant, John. *The Green Marketing Manifesto*. West Sussex, England: John Wiley & Sons, 2007.

McDonough, William, and Michael Braungart. *Cradle to Cradle: Remaking the Way We Make Things*. New York: North Point Press, 2002.

Pearce, David, Anil Markandya, and Edward Barbier. *Blueprint for a Green Economy*. London: Earthscan Publications, 1989.

Read, Leonard. "I, Pencil: My Family Tree as Told to Leonard E. Read." New York: Foundation for Economic Education, 1959.

Sterling, Bruce. *Shaping Things*. Cambridge, MA: MIT Press, 2005.

Photography by Daniel Alexander, except for the images
on the following pages:

Nelly Ben Hayoun: 84–85, 110, 142–43, 145, 147

Dover Publications (Georgii Agricolae, *De re metallica*, 1950): 55

Simon Gretton: 47 (bottom), 48, 92–95, 97, 123, 127

Home Retail Group PLC: 14, 39

Austin Houldsworth: 57–67

Xiaodi Huang and Jiann-Yang Hwang: 76

Dr. Jill Key, Sue Reid, and Shell Education Service: 104

A Young Kim: 152

NASA: 47 (top), 91, 122, 140

Eric Norcross: 33

Thomas Thwaites: 22–23, 28, 50–54, 56, 70–71, 82–83, 121,
 128, 141, 149, 163–65

Thomas Thwaites with thanks to John Lewis Partnership:
 184–85

Christos Vittoratos: 32